D0817181

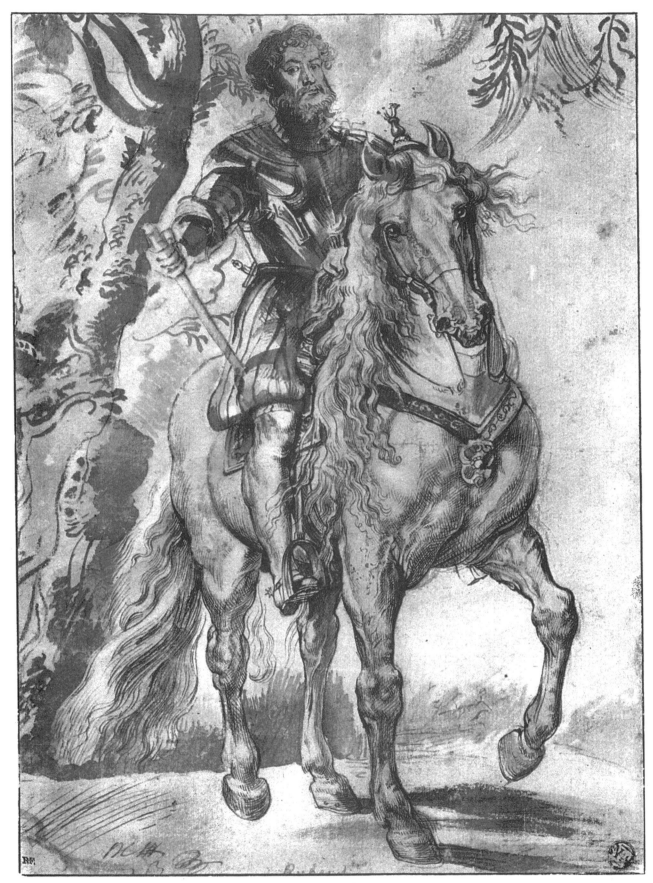

PETER PAUL RUBENS

Great Animal Drawings and Prints

Edited by
Carol Belanger Grafton

Dover Publications, Inc.
Mineola, New York

Copyright

Copyright © 2006 by Dover Publications, Inc.
All rights reserved.

Bibliographical Note

Great Animal Drawings and Prints is a new work, first published by Dover Publications, Inc., in 2006.

DOVER *Pictorial Archive* SERIES

This book belongs to the Dover Pictorial Archive Series. You may use the designs and illustrations for graphics and crafts applications, free and without special permission, provided that you include no more than four in the same publication or project. (For permission for additional use, please write to Permissions Department, Dover Publications, Inc., 31 East 2nd Street, Mineola, N.Y. 11501.)

However, republication or reproduction of any illustration by any other graphic service, whether it be in a book or in any other design resource, is strictly prohibited.

International Standard Book Number: 0-486-44830-4

Manufactured in the United States of America
Dover Publications, Inc., 31 East 2nd Street, Mineola, N.Y. 11501

LIST OF PLATES

COLOR SECTION

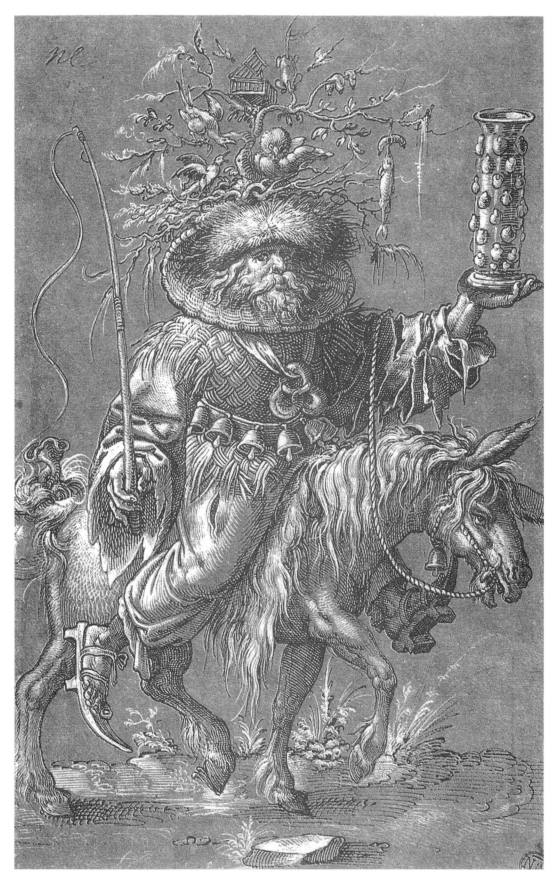

Plate 1. JOST AMMAN

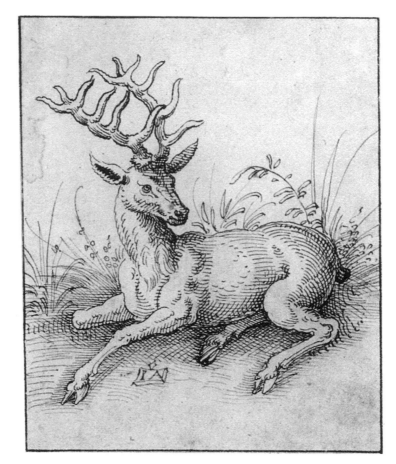

Plate 2. JOST AMMAN

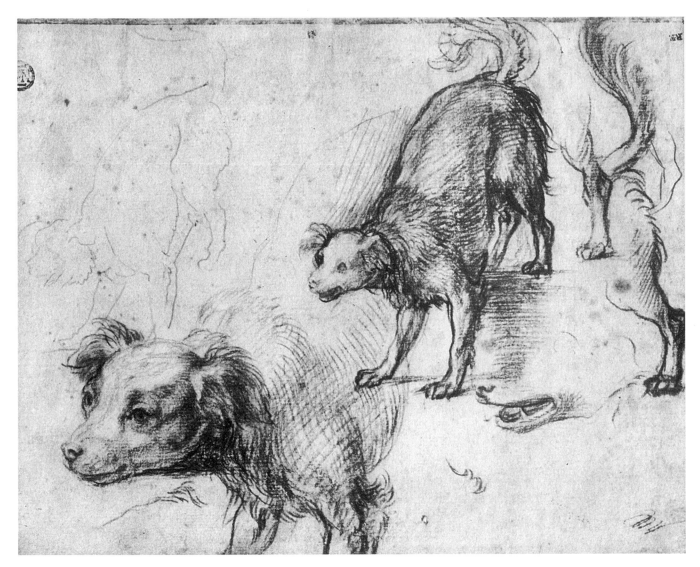

Plate 3. ANDREA DEL SARTO

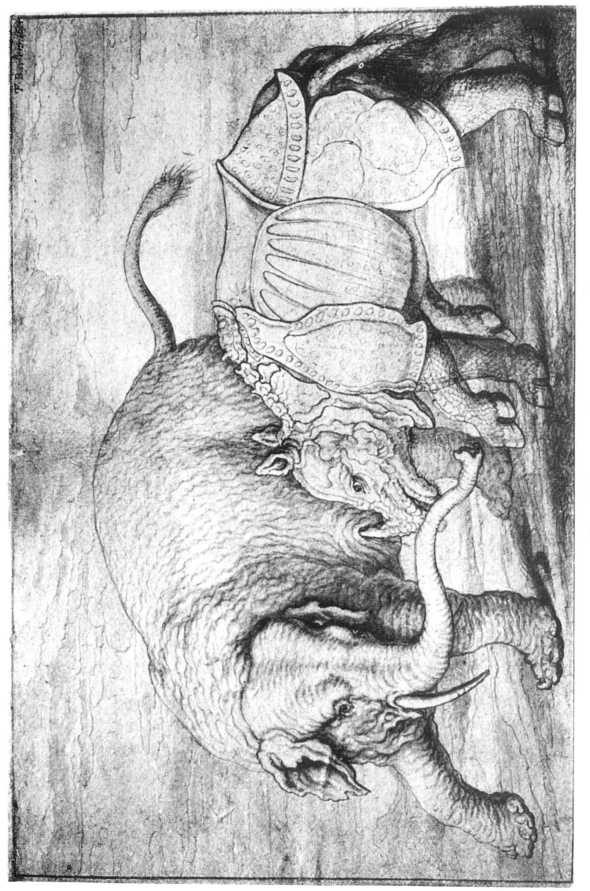

Plate 4. FRANCIS BARLOW

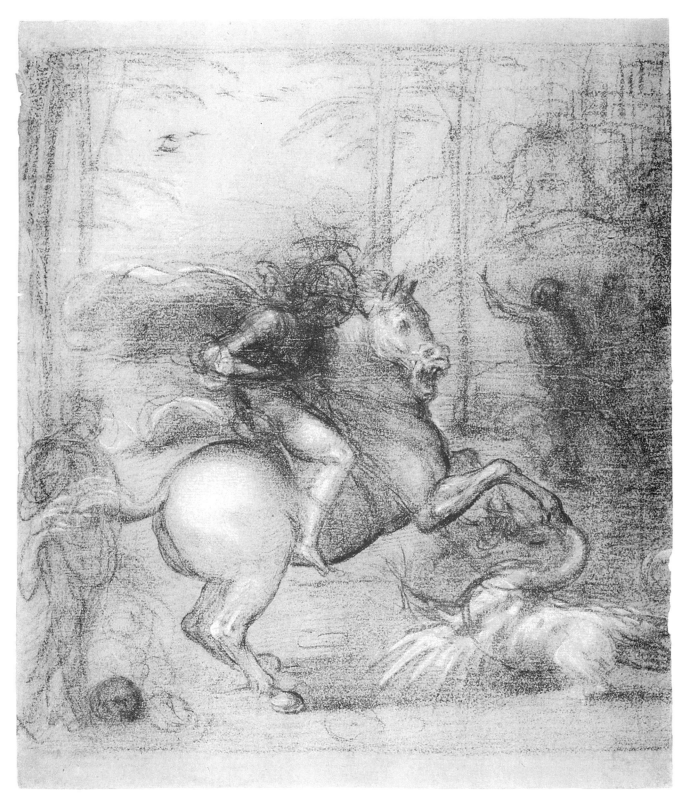

Plate 5. FRA BARTOLOMMEO

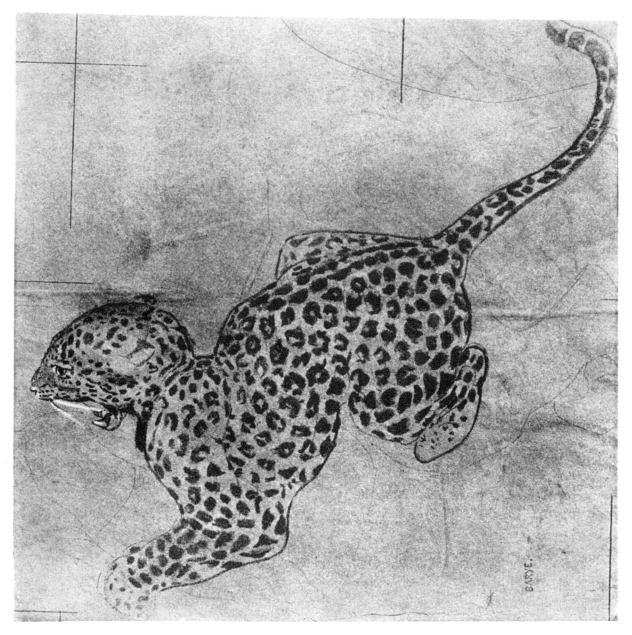

Plate 6. ANTOINE-LOUIS BARYE

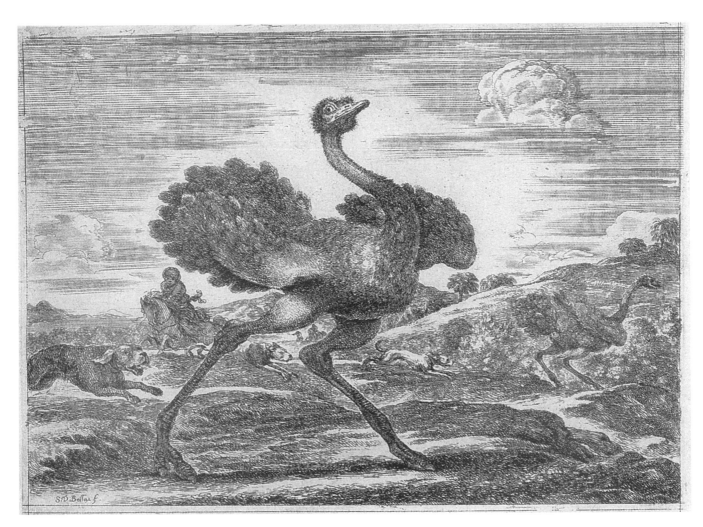

Plate 7. STEFANO DELLA BELLA

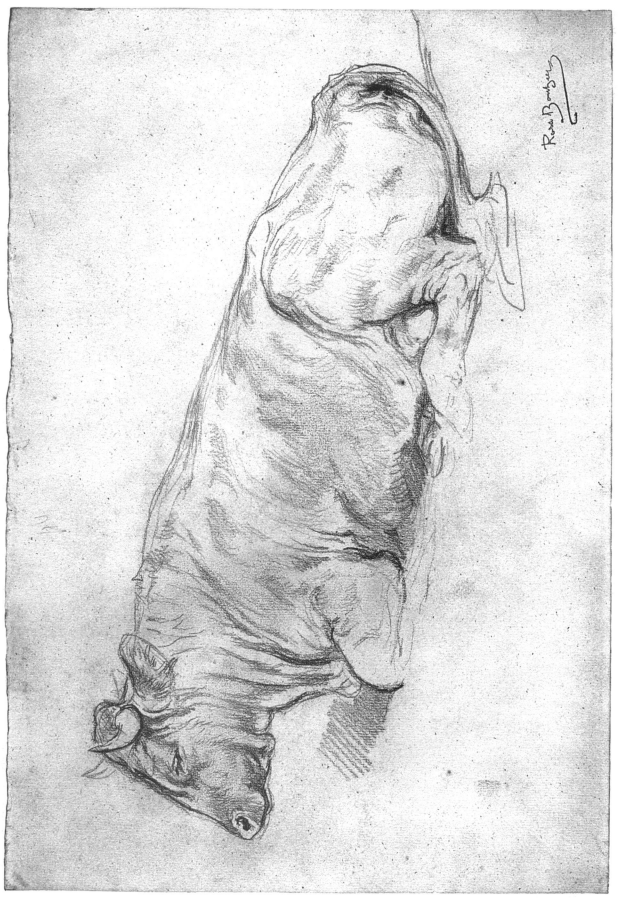

Plate 8. ROSA BONHEUR

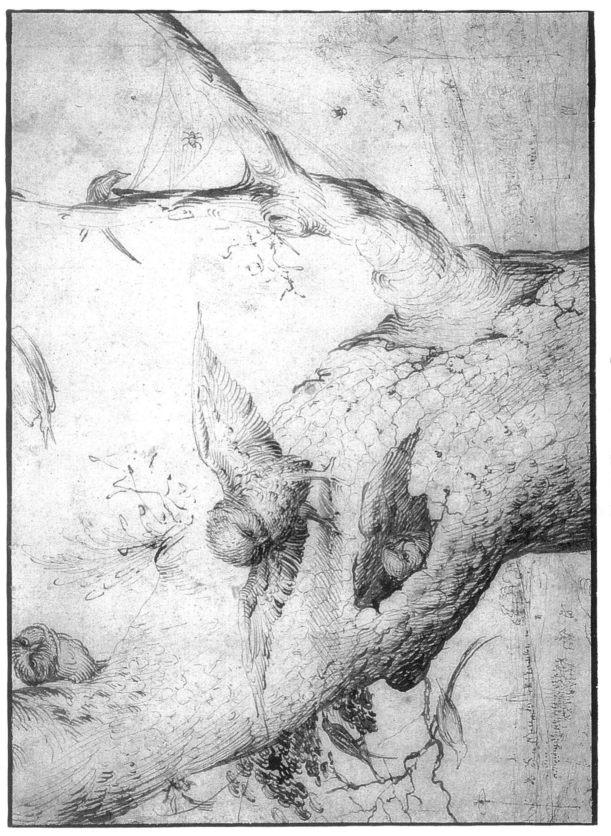

Plate 9. HIERONYMUS BOSCH

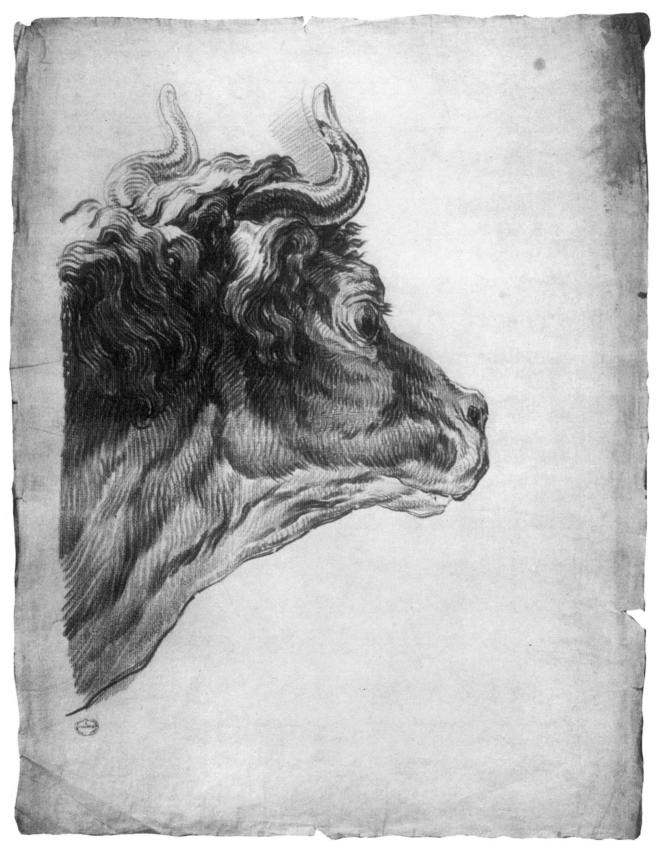

Plate 10. EDMÉ BOUCHARDON

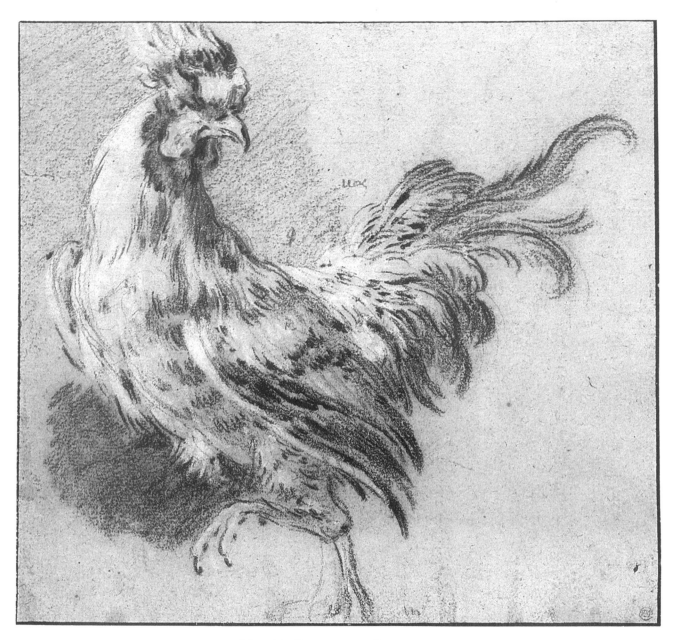

Plate 11. FRANÇOIS BOUCHER

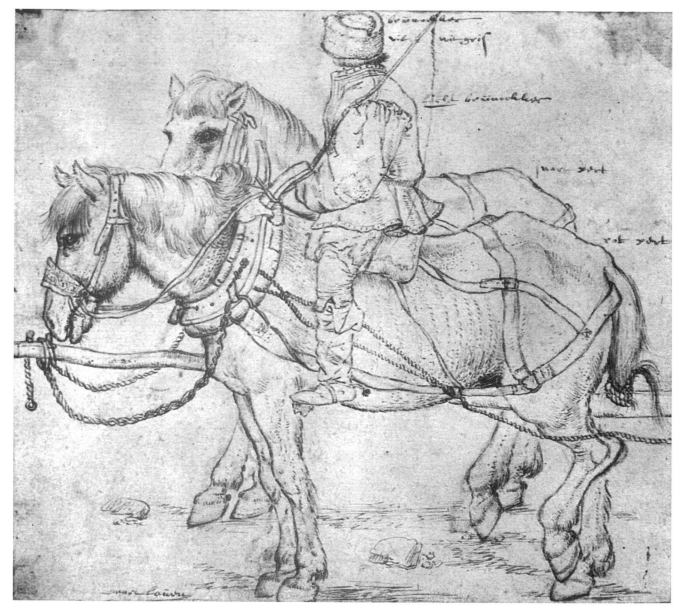

Plate 12. Pieter Bruegel the Elder

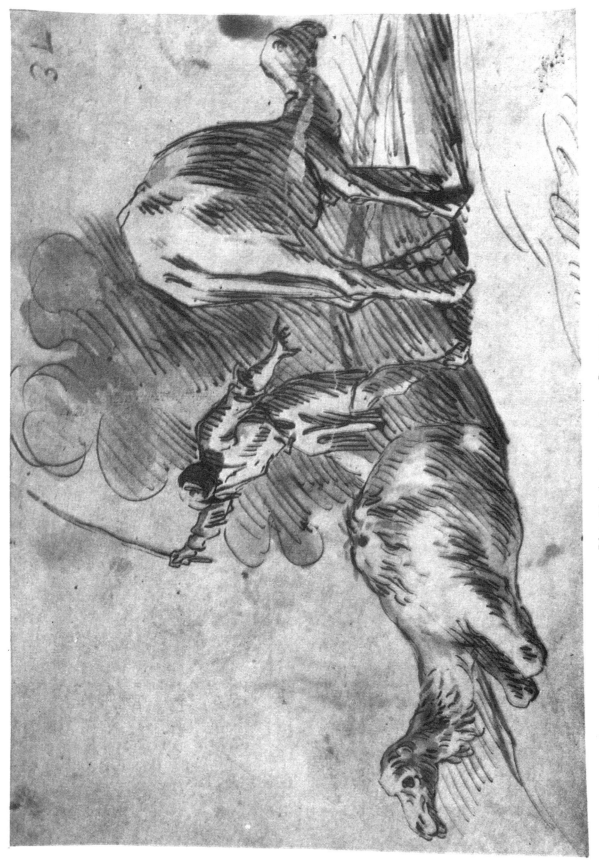

Plate 13. ANTONIO DEL CASTILLO

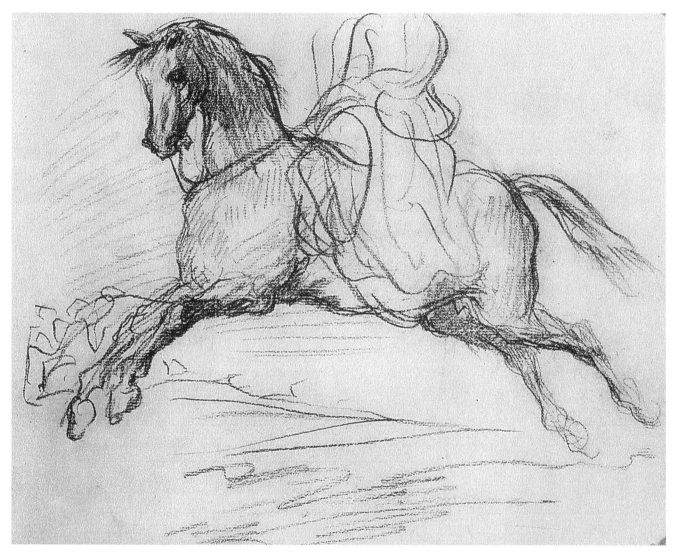

Plate 14. Théodore Chassériau

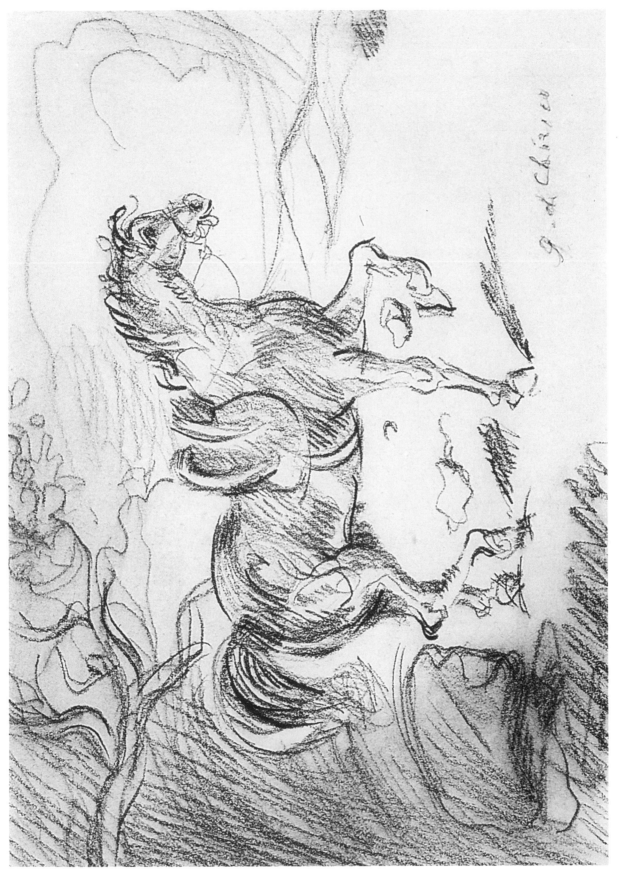

Plate 15. GIORGIO DE CHIRICO

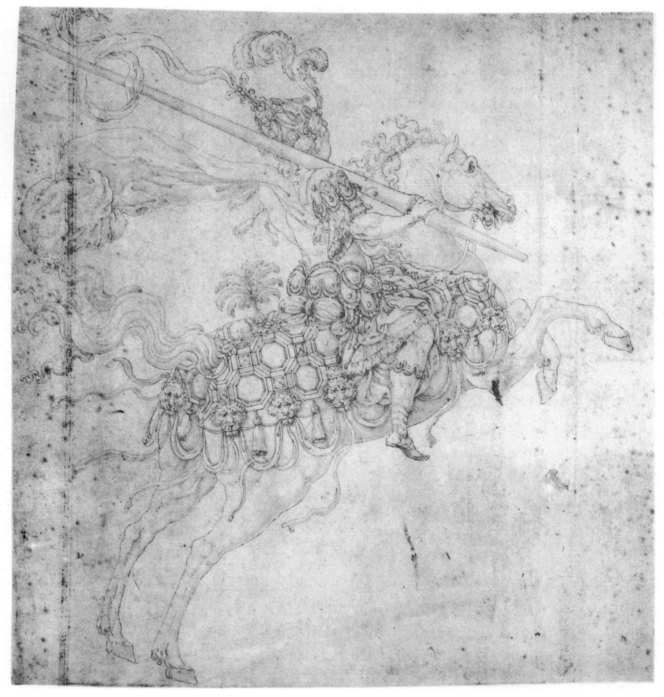

Plate 16. ALLAERT CLAESZ

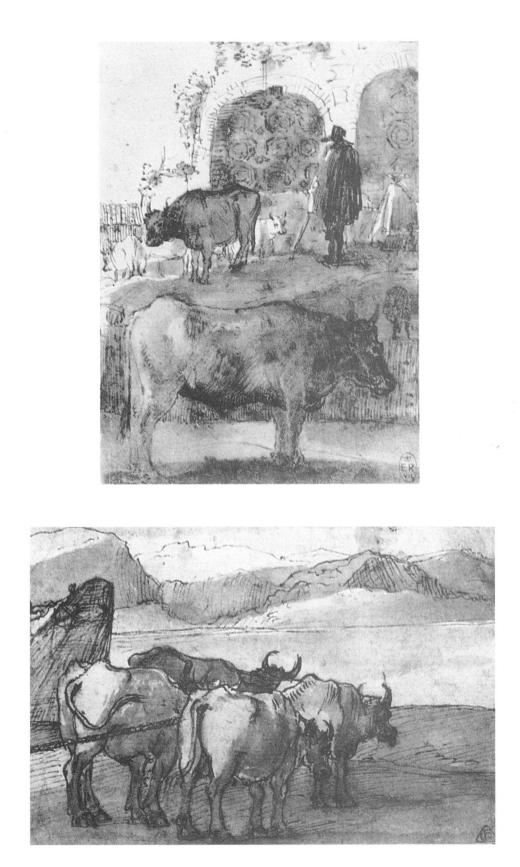

Plate 17. CLAUDE (CLAUDE LORRAIN)

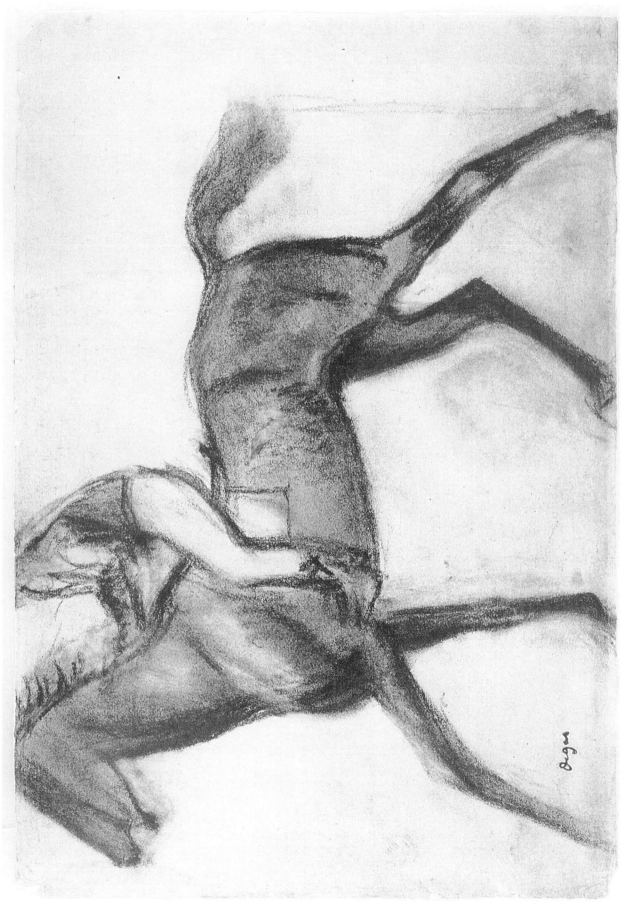

Plate 18. Edgar Degas

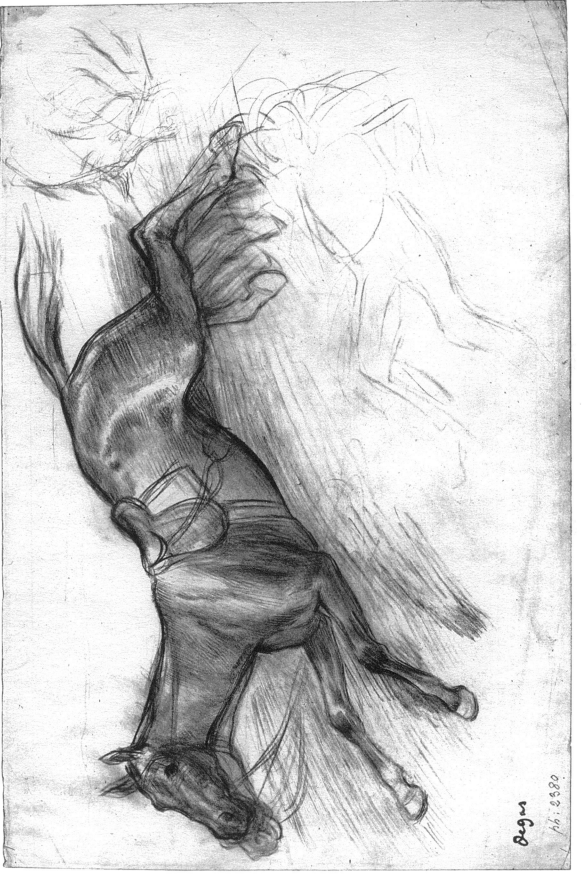

Plate 19. EDGAR DEGAS

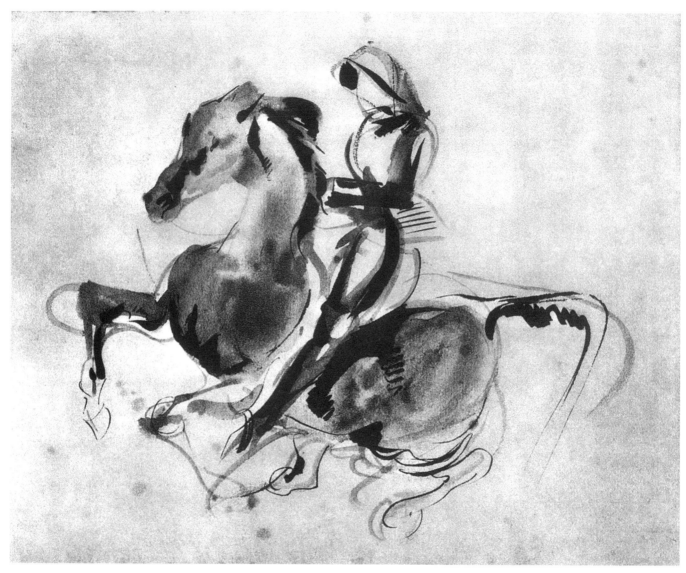

Plate 20. Eugène Delacroix

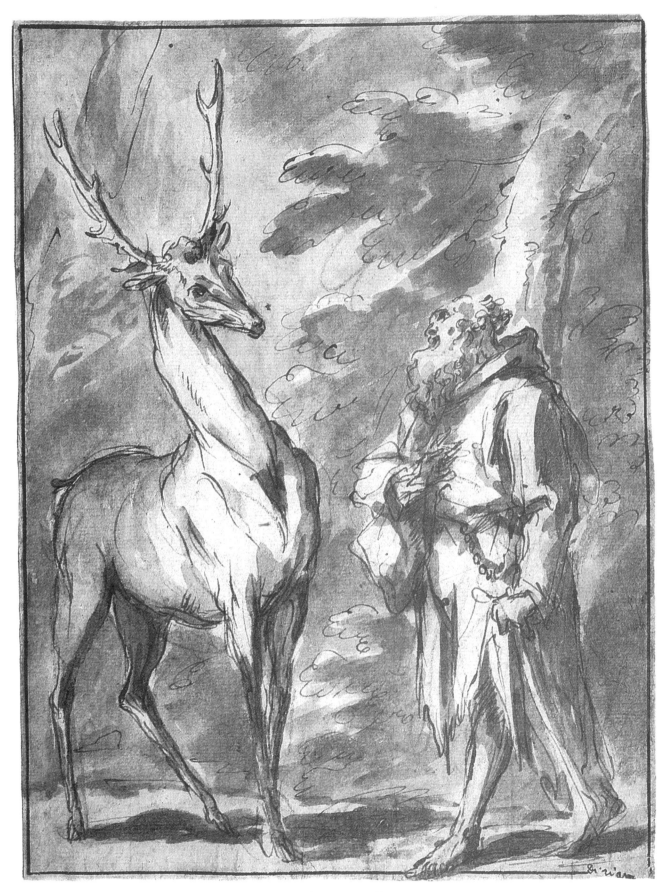

Plate 21. GASPARE DIZIANI

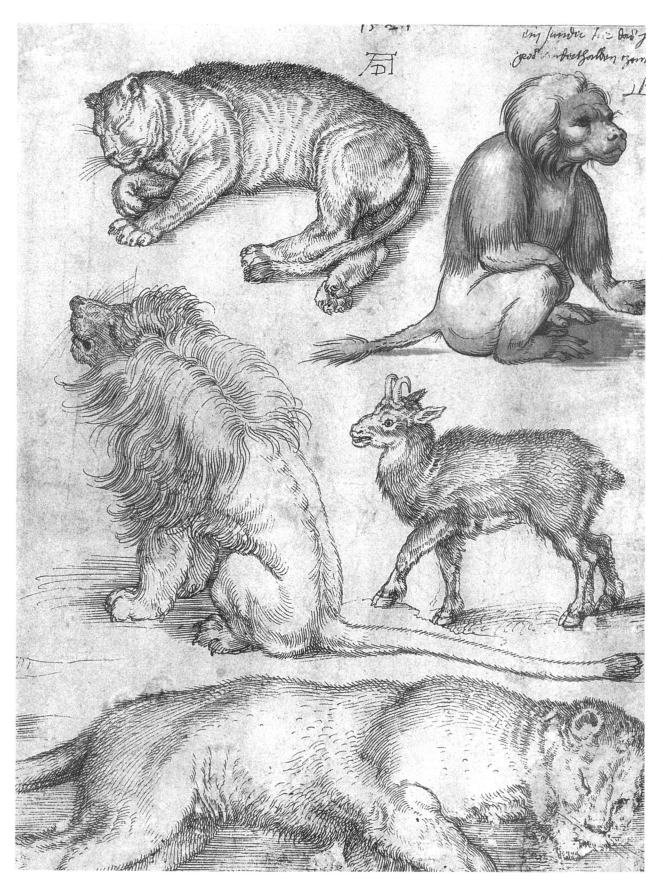

Plate 22. ALBRECHT DÜRER

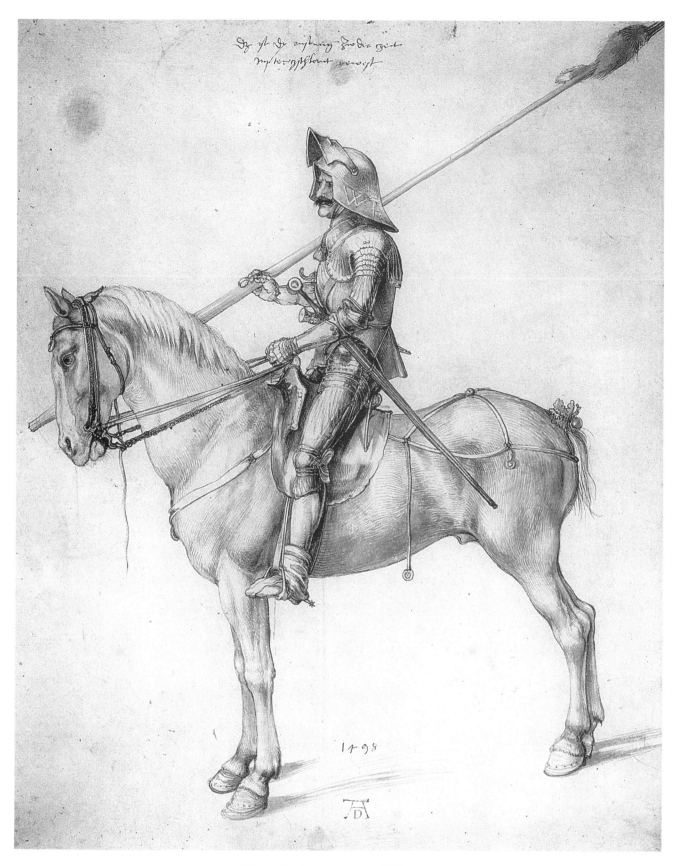

Plate 23. ALBRECHT DÜRER

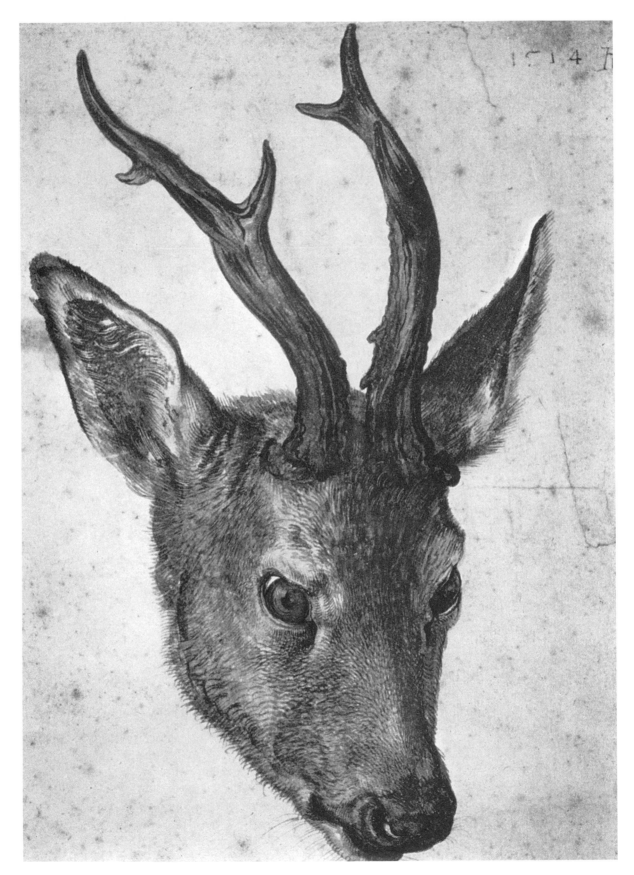

Plate 24. ALBRECHT DÜRER

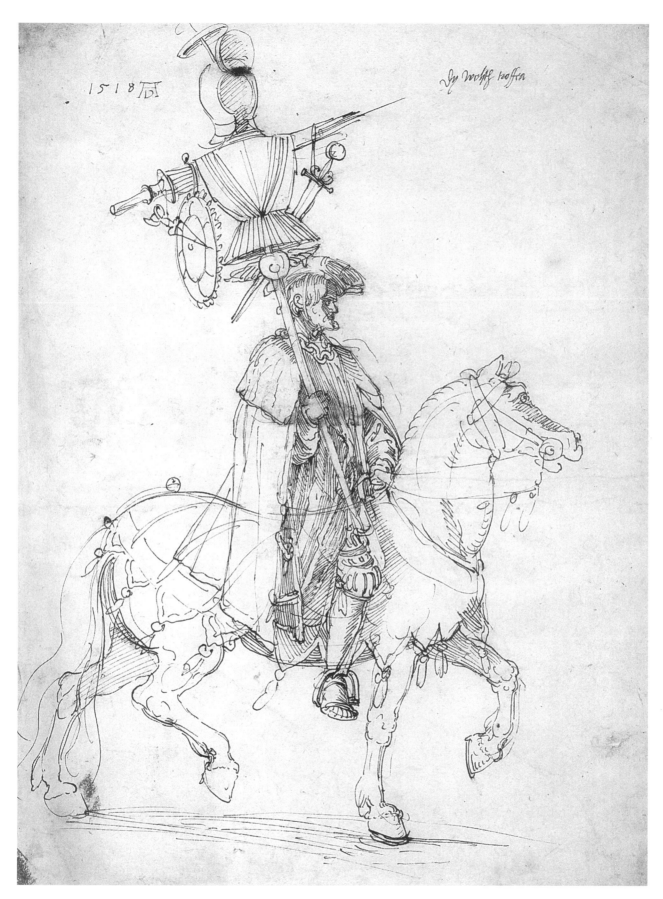

Plate 25. ALBRECHT DÜRER

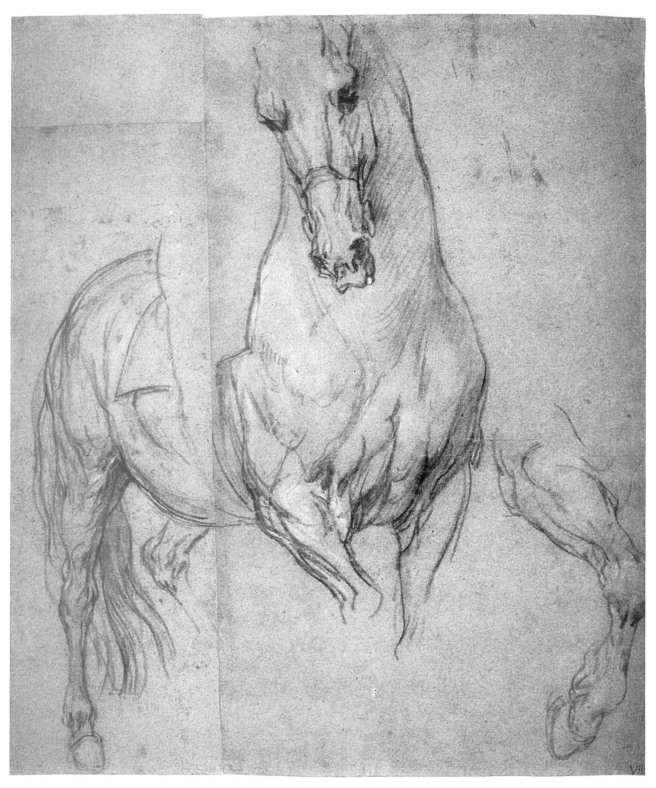

Plate 26. ANTHONY VAN DYCK

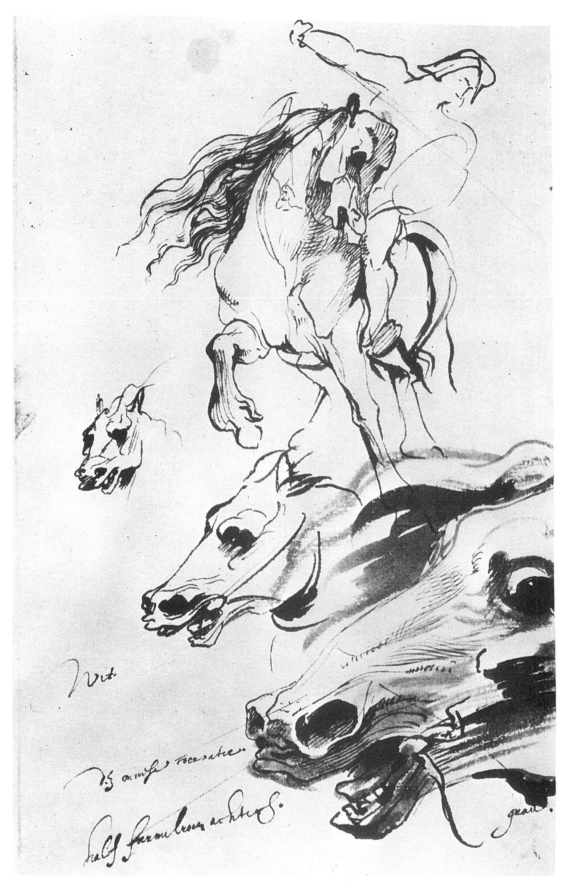

Plate 27. ANTHONY VAN DYCK

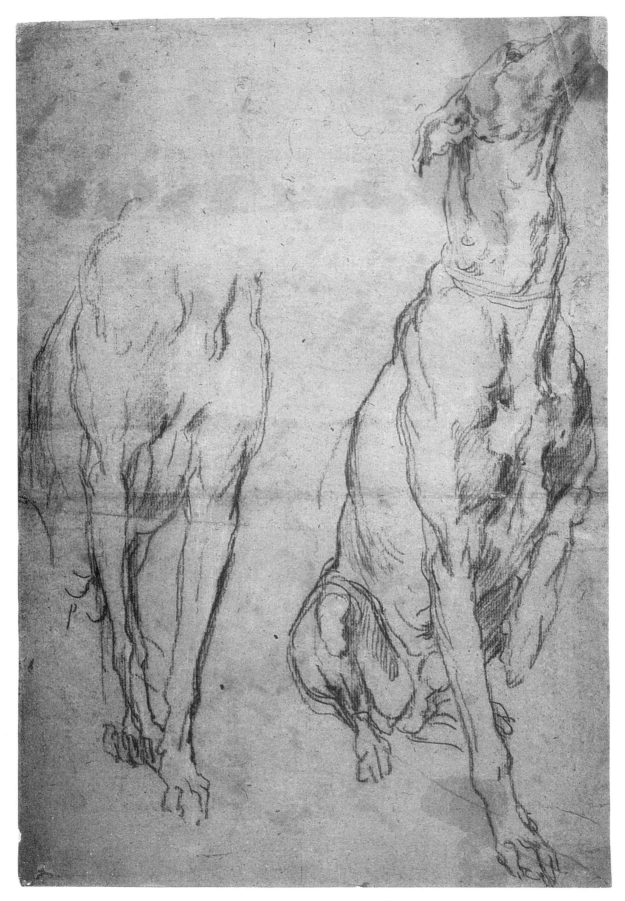

Plate 28. ANTHONY VAN DYCK

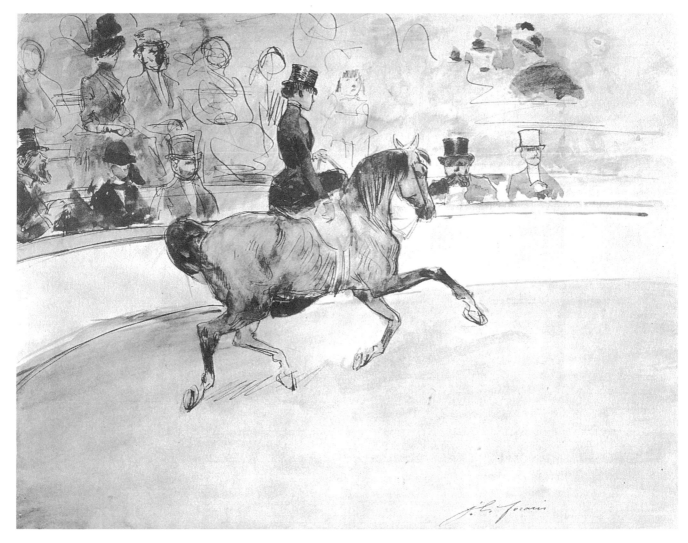

Plate 29. Jean-Louis Forain

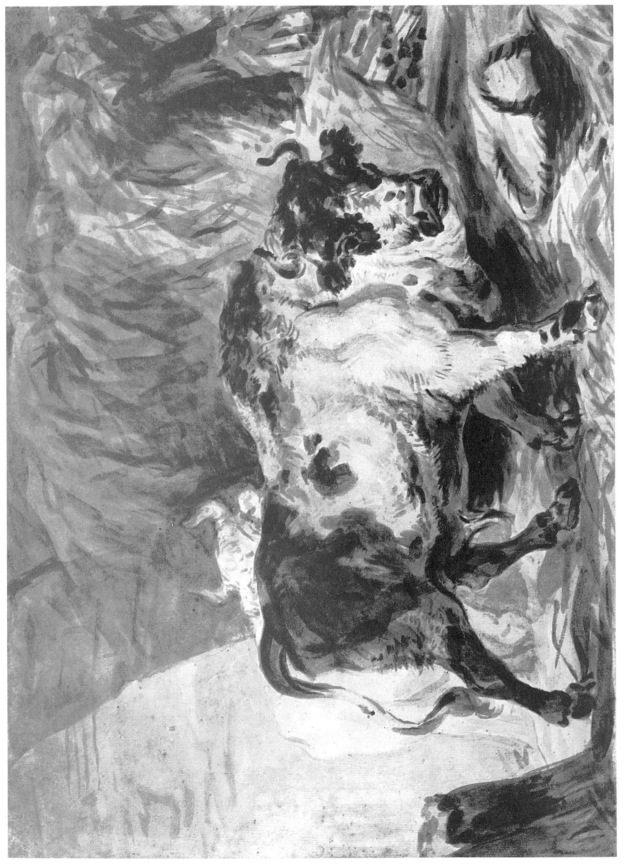

Plate 30. JEAN-HONORÉ FRAGONARD

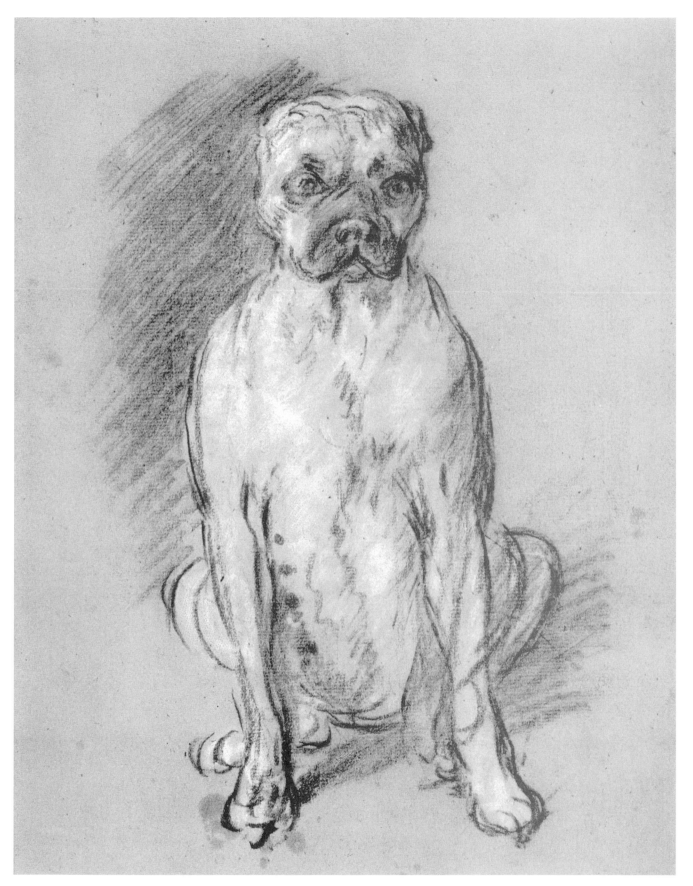

Plate 31. Thomas Gainsborough

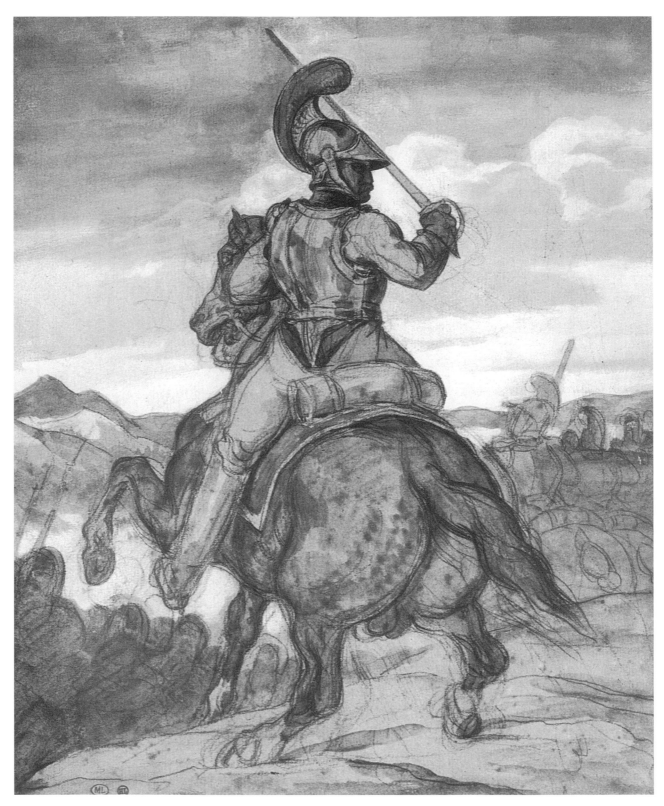

Plate 32. Jean-Louis-André-Théodore Géricault

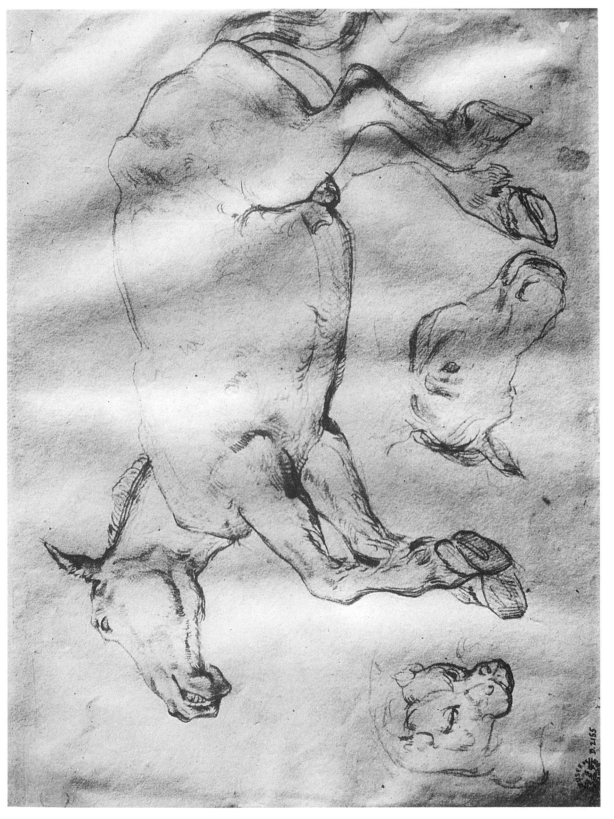
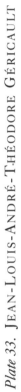

Plate 33. Jean-Louis-André-Théodore Géricault

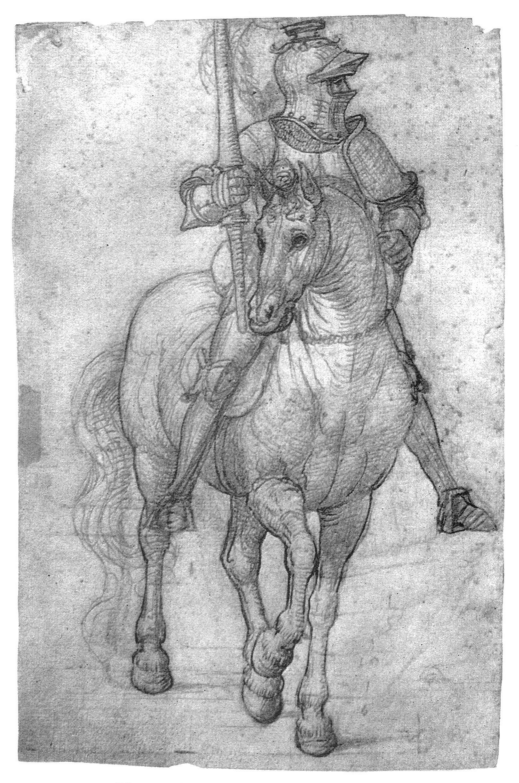

Plate 34. GERMAN MASTER, ANONYMOUS

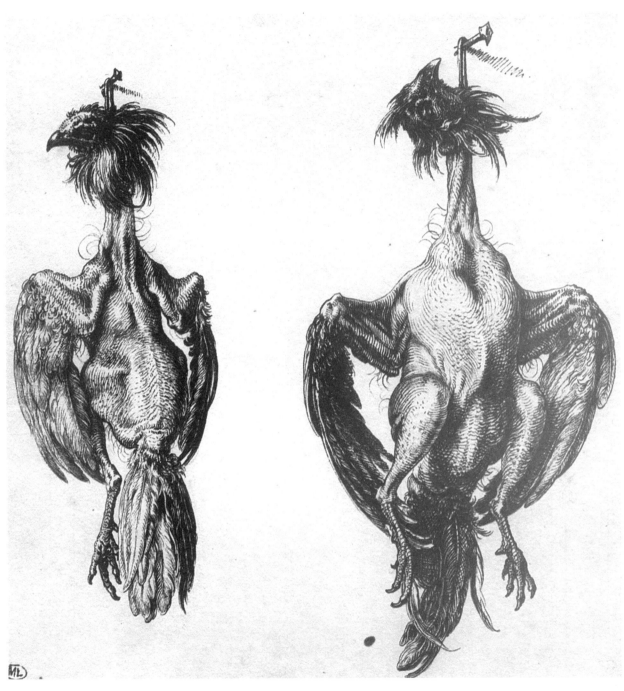

Plate 35. Jacob de Gheyn II

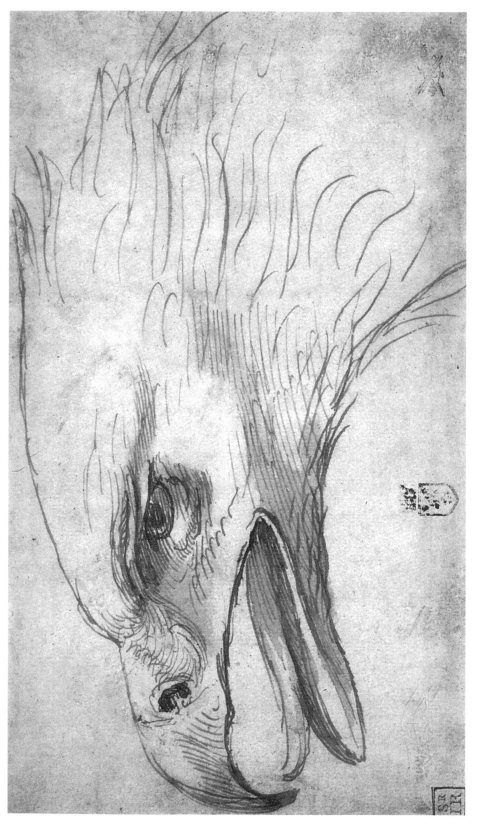

Plate 36. Giulio Pippi (called Giulio Romano)

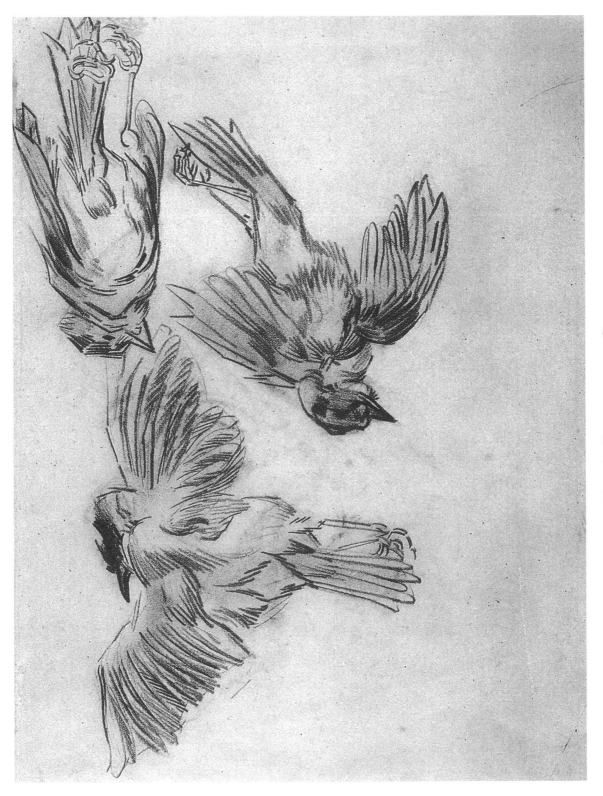

Plate 37. VINCENT VAN GOGH

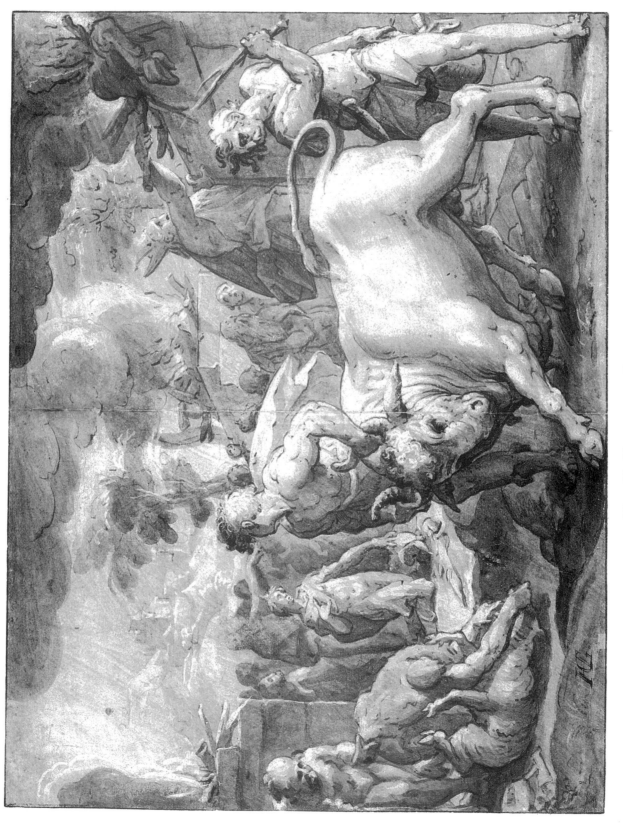

Plate 38. HENDRICK GOLTZIUS

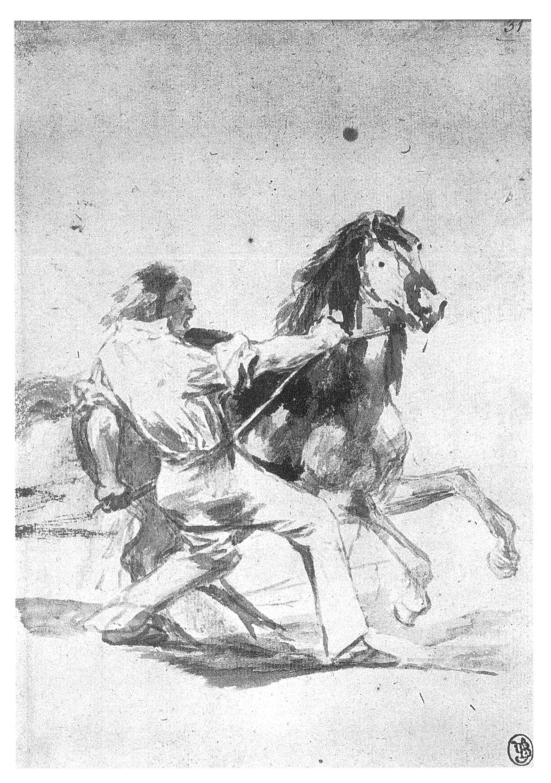

Plate 39. Francisco Goya

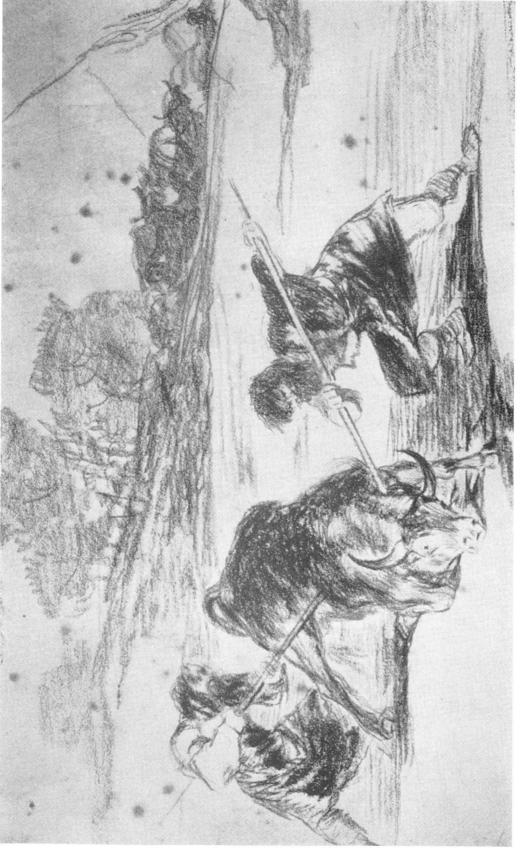

Plate 40. Francisco Goya

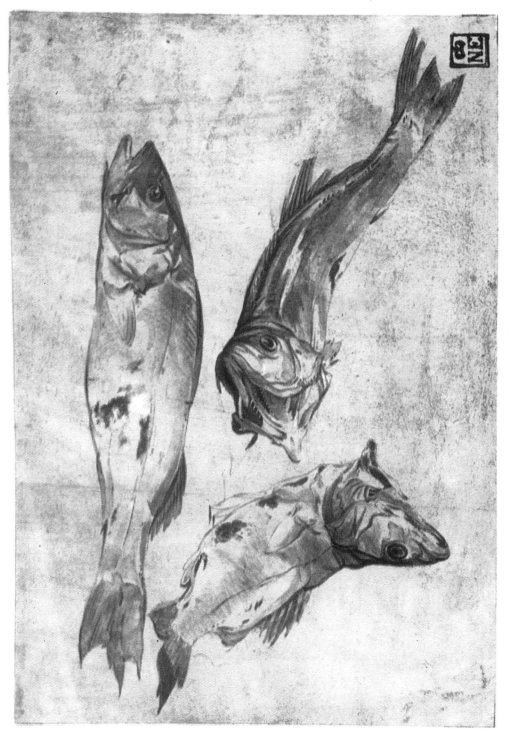

Plate 41. HANS HOFFMANN

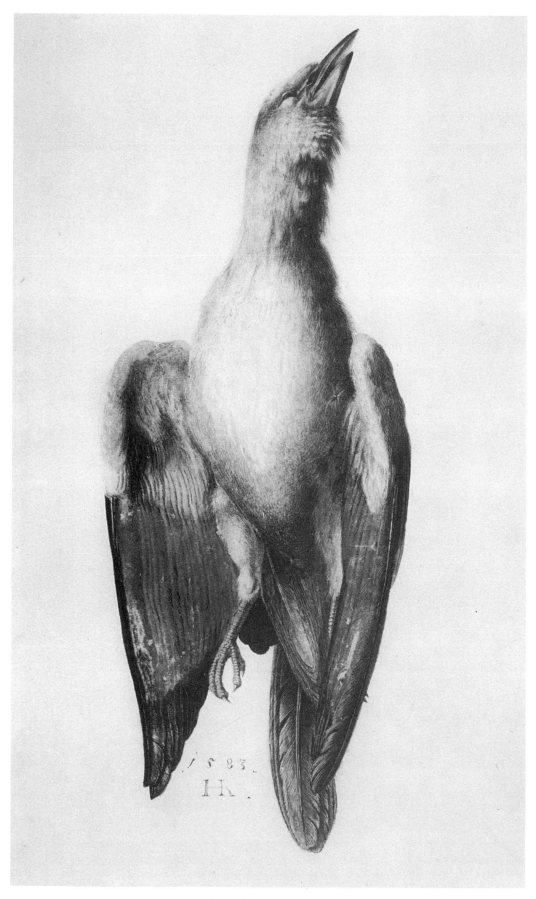

Plate 42. HANS HOFFMANN

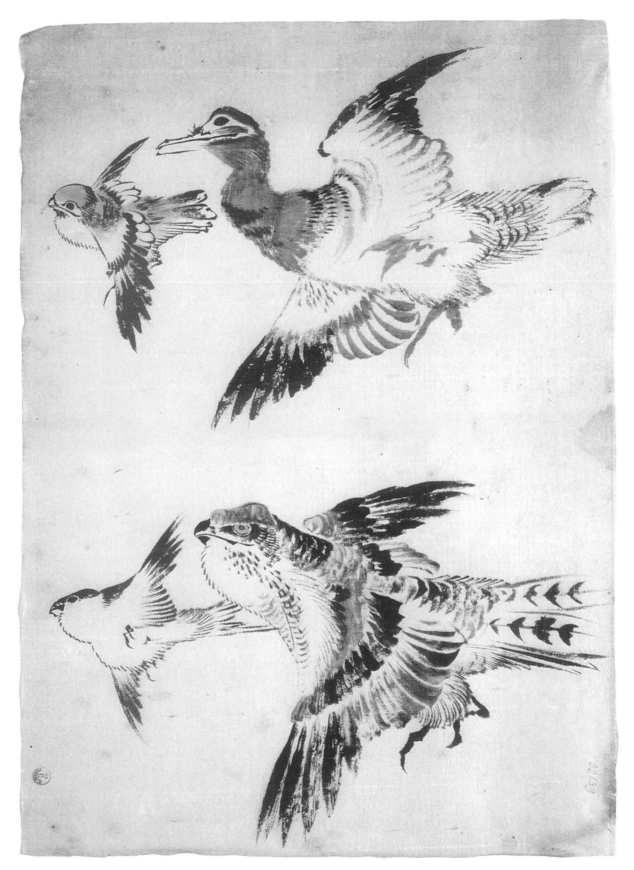

Plate 43. KATSUSHIKA HOKUSAI

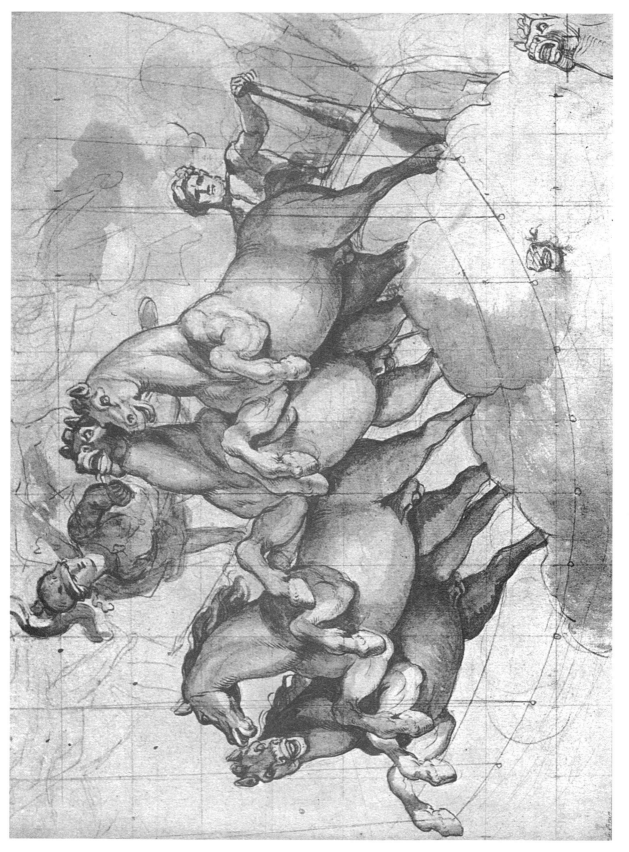

Plate 44. Charles Le Brun

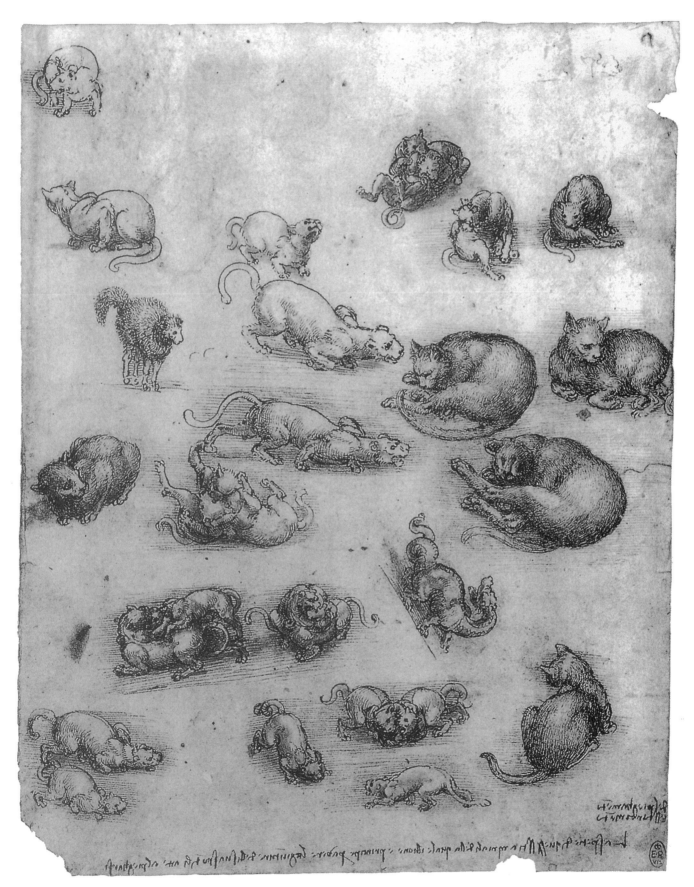

Plate 45. LEONARDO DA VINCI

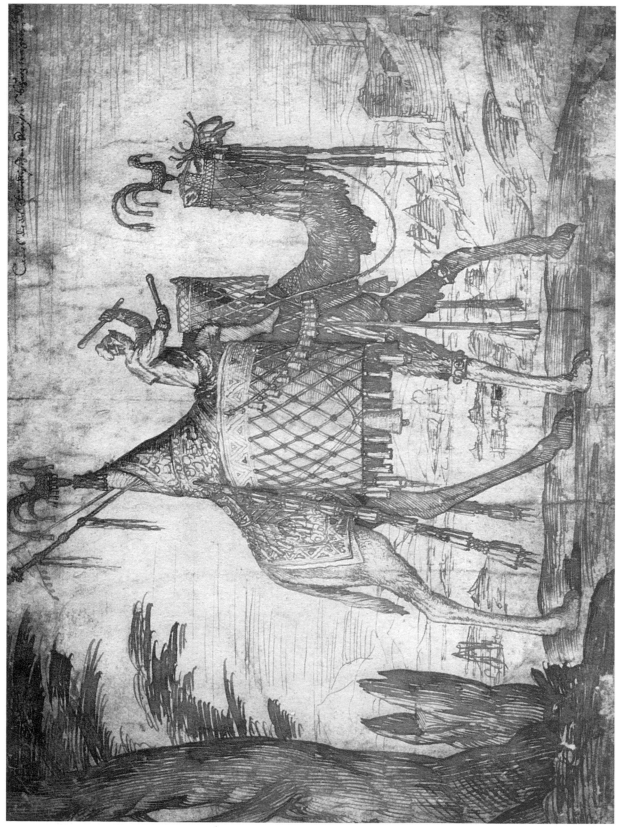

Plate 46. MELCHIOR LORCH

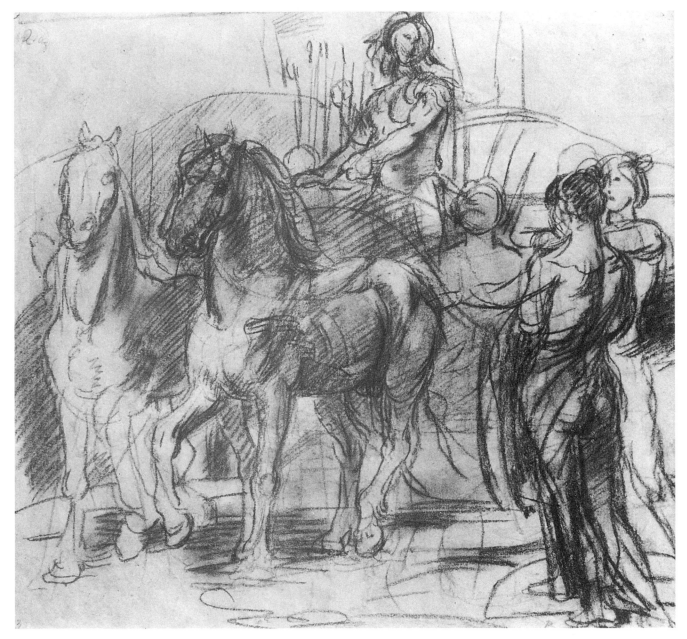

Plate 47. HANS VON MARÉES

Plate 48. CHAO MENG-FU (WU-HSING)

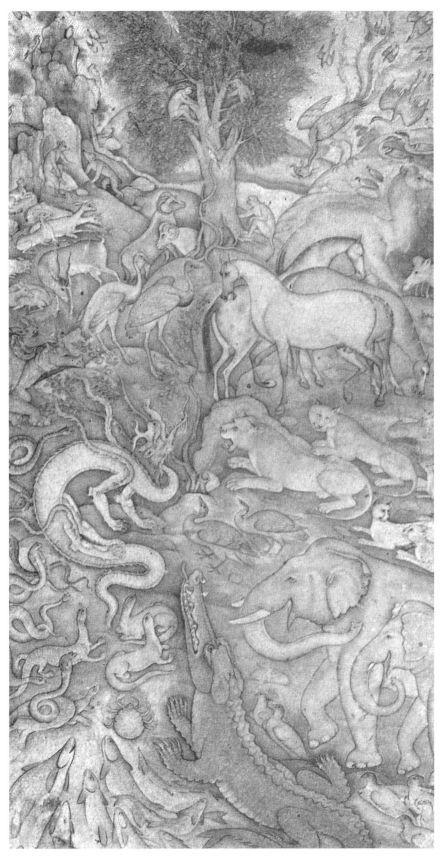

Plate 49. MIDDLE EAST, MUGHAL INDIA, ANONYMOUS

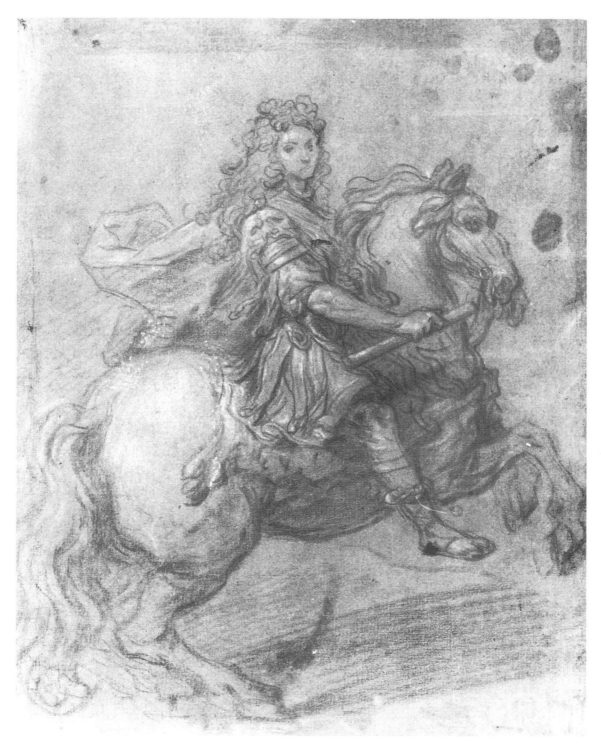

Plate 50. PIERRE MIGNARD

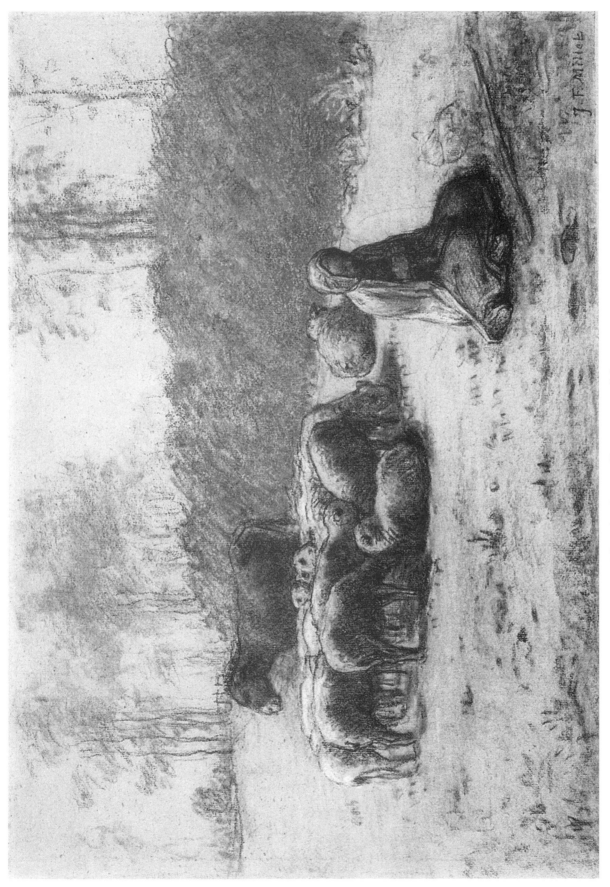

Plate 51. Jean-François Millet

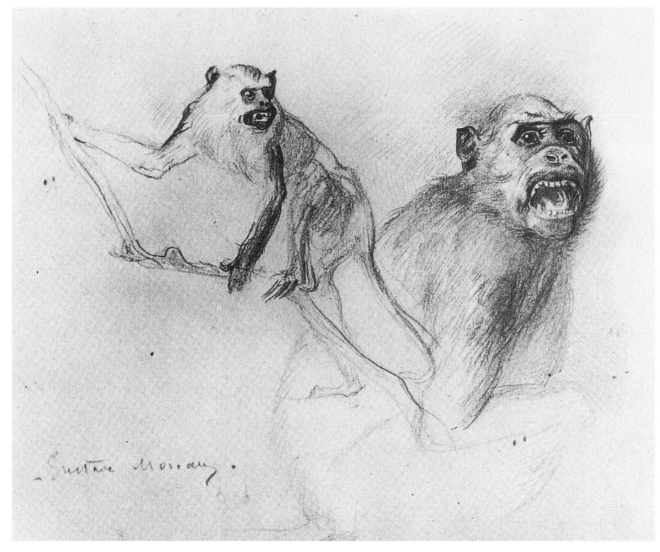

Plate 52. GUSTAVE MOREAU

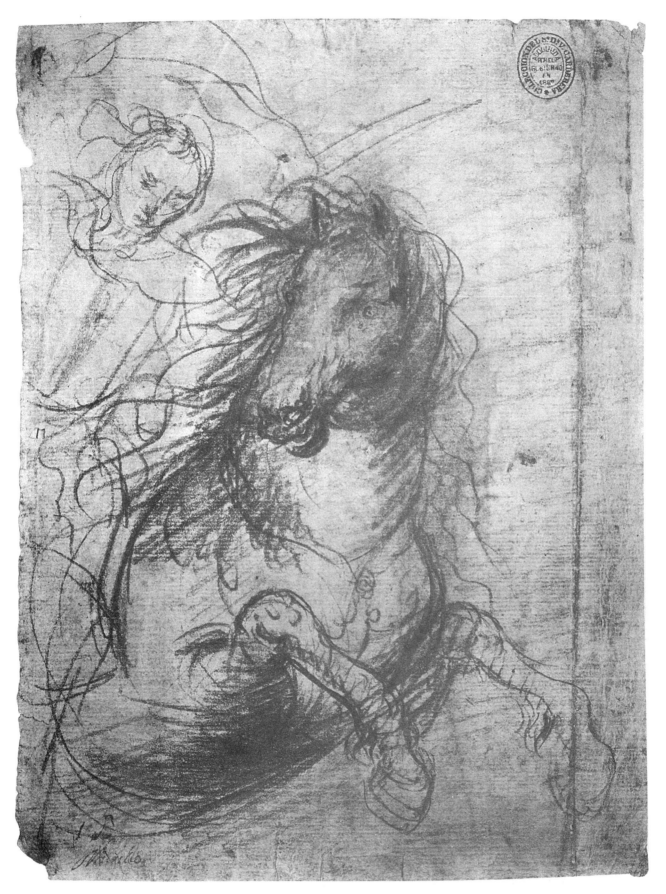

Plate 53. BARTOLOMÉ ESTEBAN MURILLO

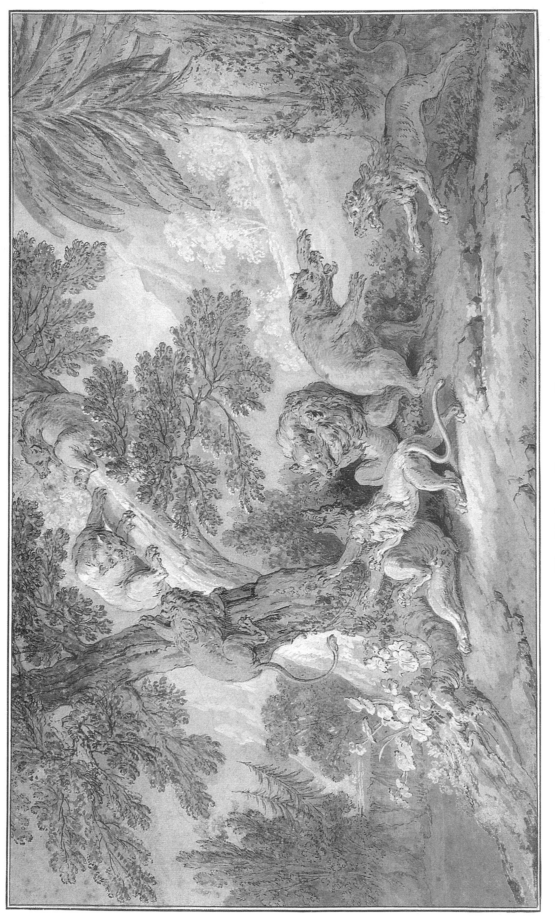

Plate 54. Jean-Baptiste Oudry

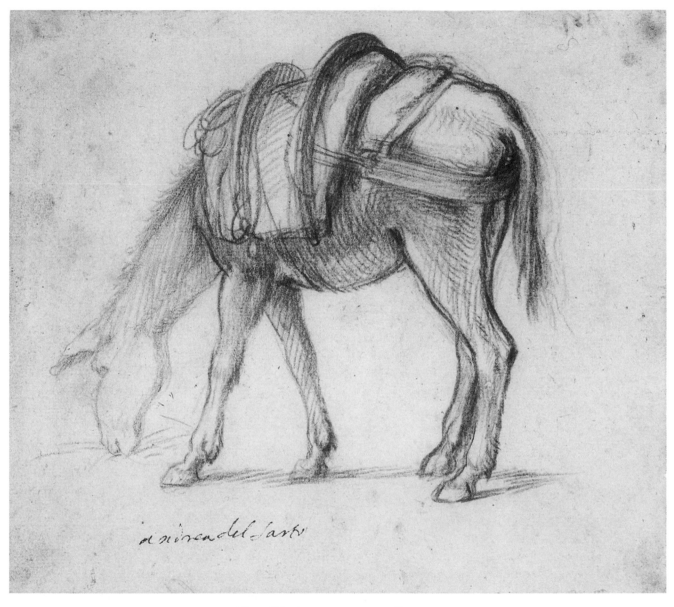

Plate 55. ANDREA DEL SARTO

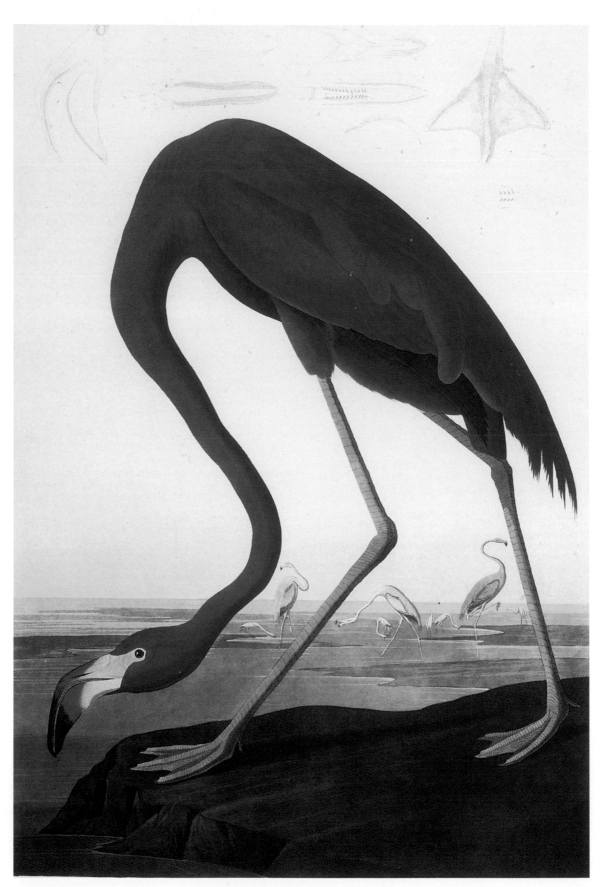

Plate 56. JOHN JAMES AUDUBON

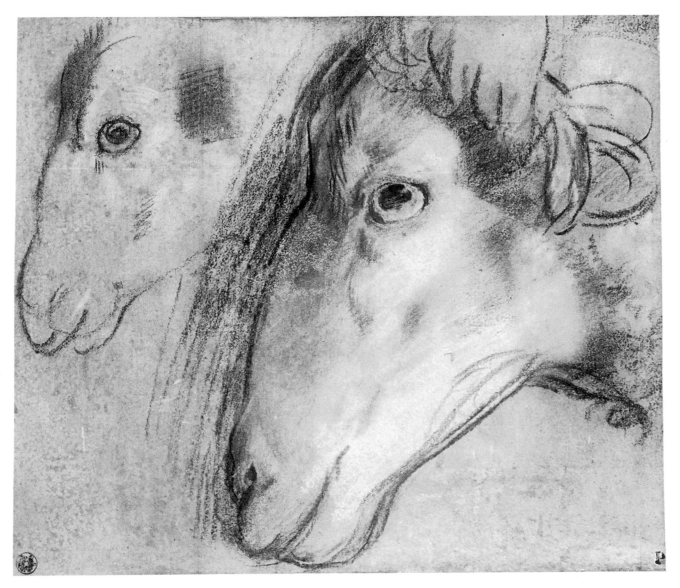

Plate 57. FEDERIGO BAROCCI

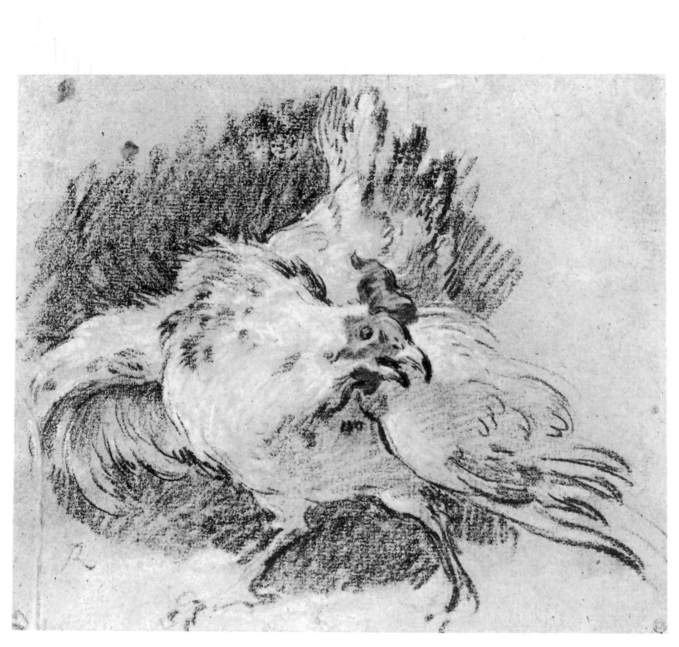

Plate 58. FRANÇOIS BOUCHER

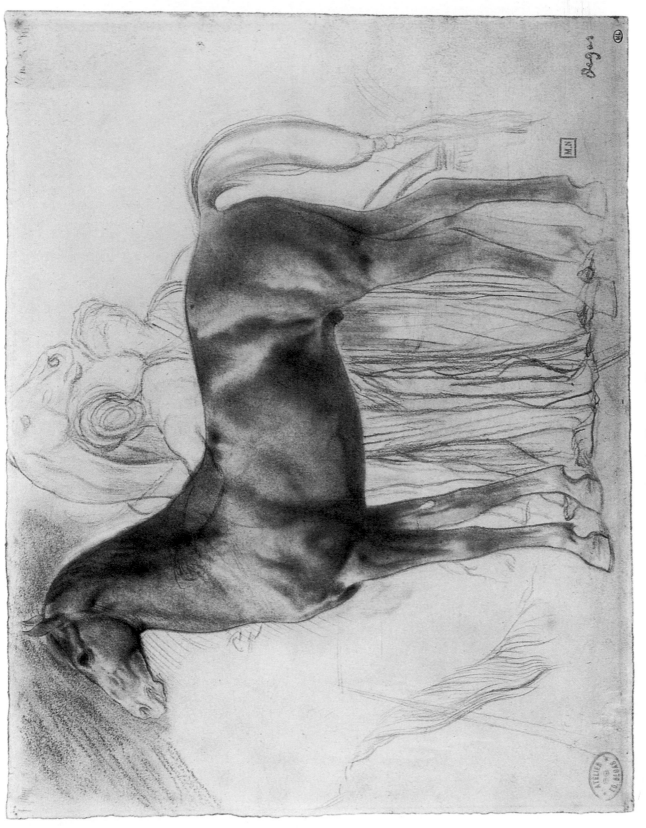

Plate 59. E<small>DGAR</small> D<small>EGAS</small>

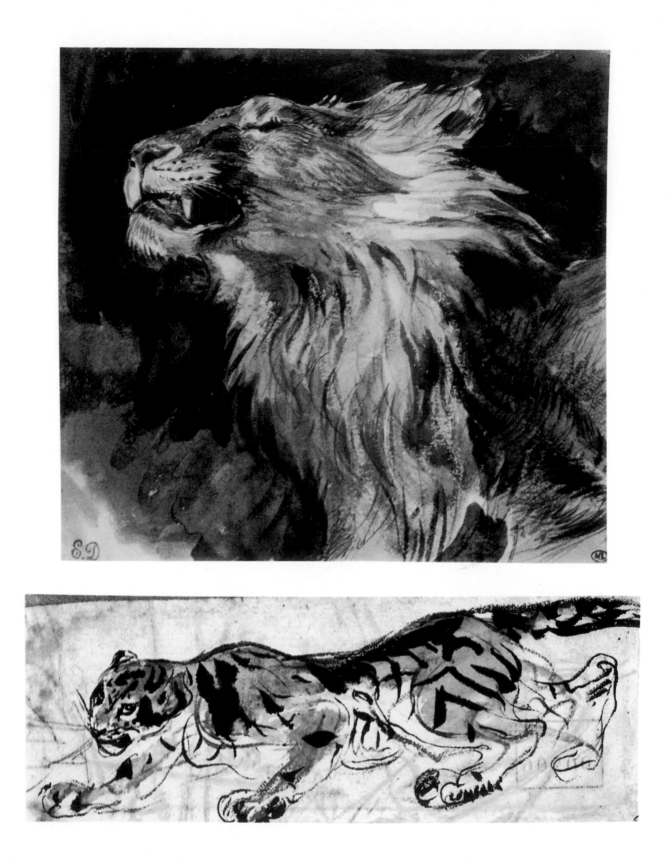

Plate 60. Eugène Delacroix

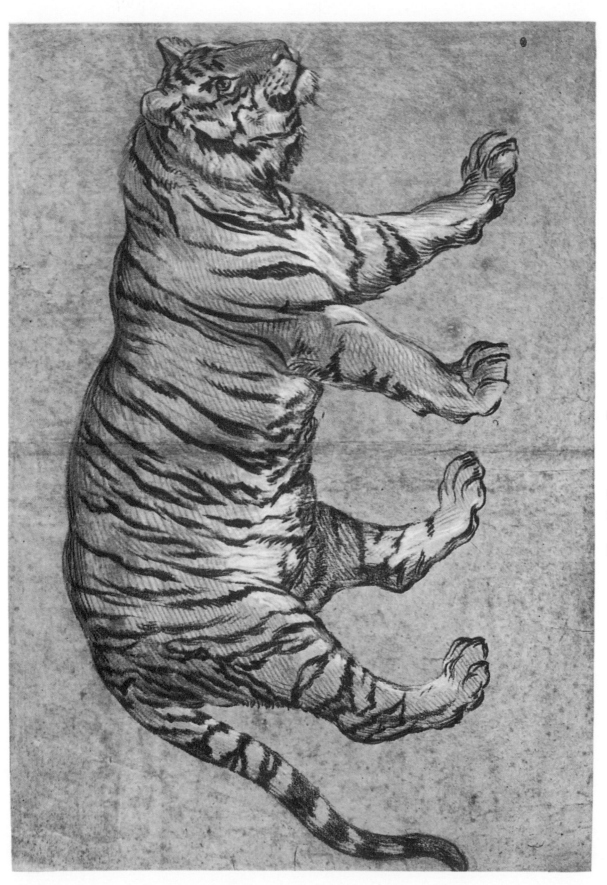

Plate 61. FRANÇOIS DESPORTES

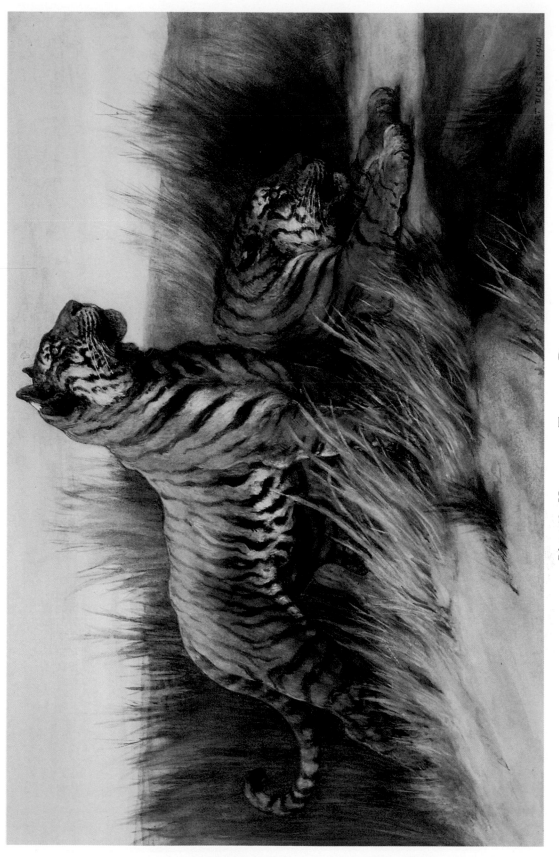

Plate 62. HERBERT THOMAS DICKSEE

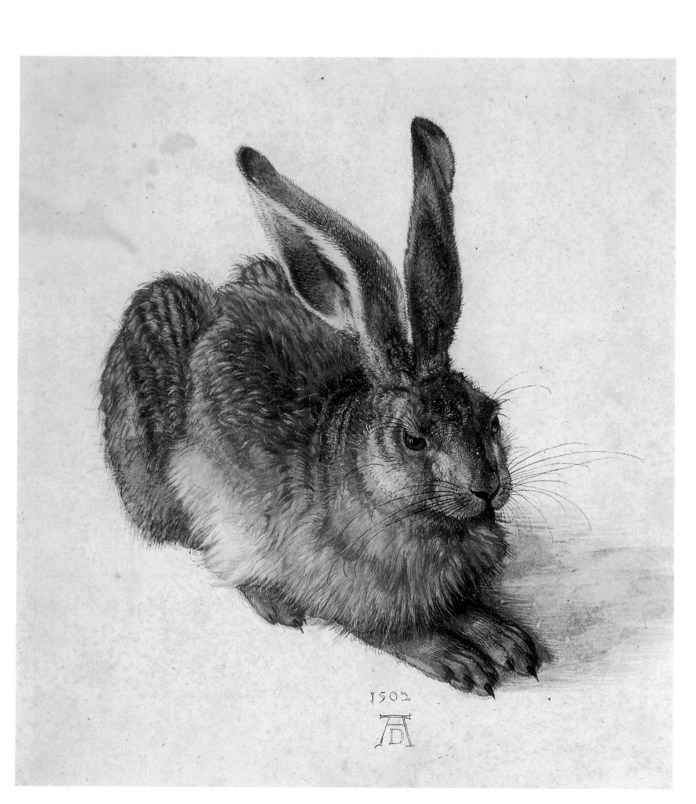

1502

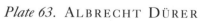

Plate 63. ALBRECHT DÜRER

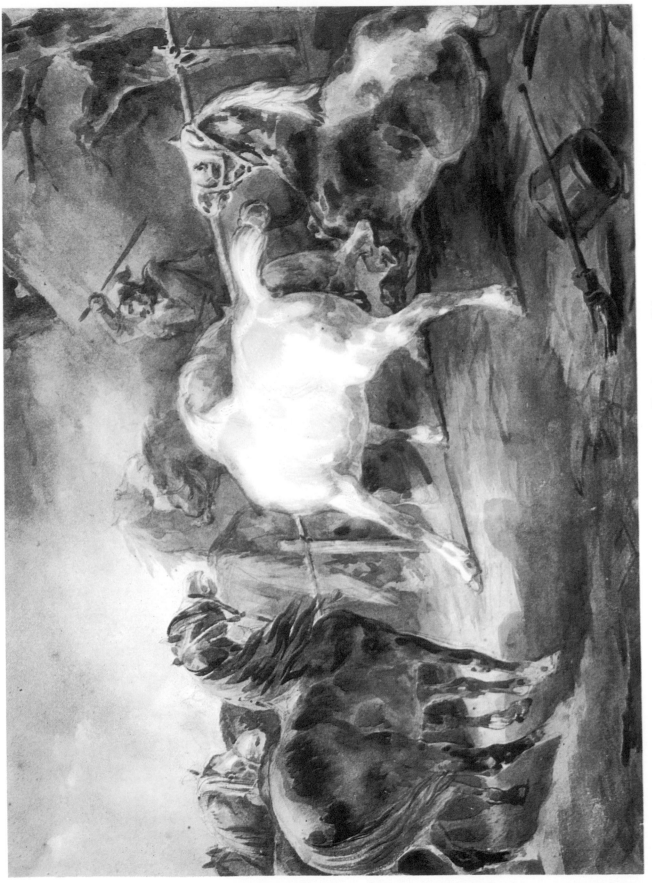

Plate 64. JEAN-LOUIS-ANDRÉ-THÉODORE GÉRICAULT

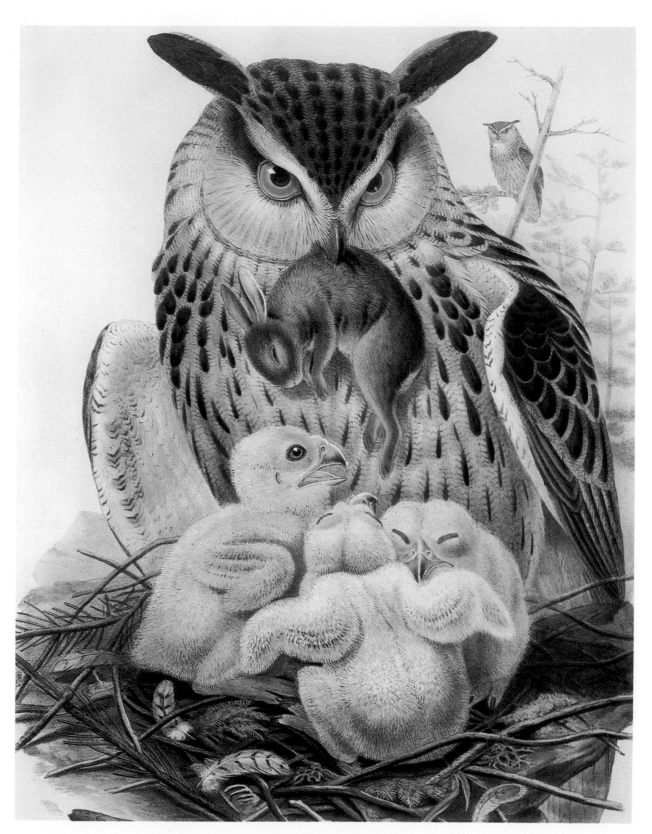

Plate 65. JOHN GOULD

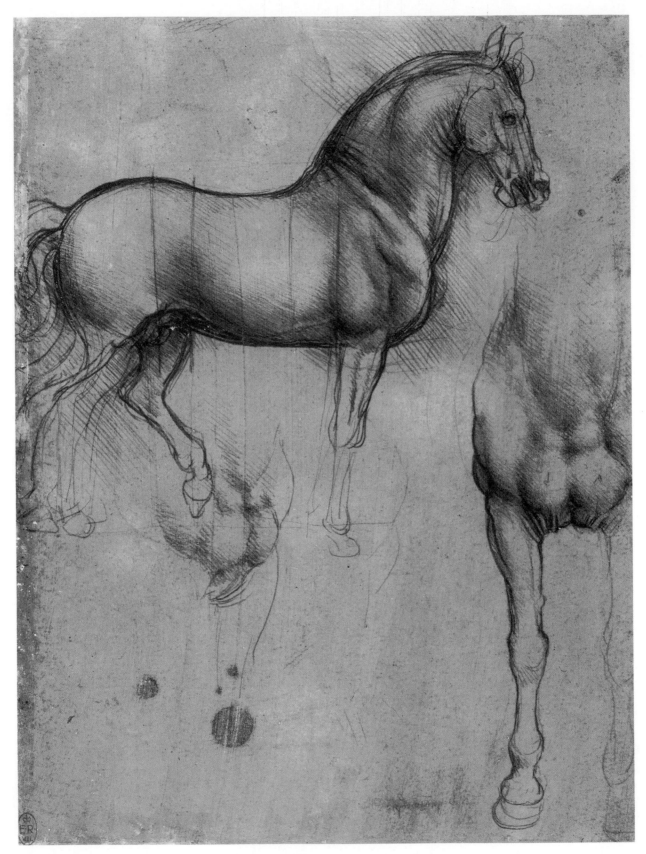

Plate 66. LEONARDO DA VINCI

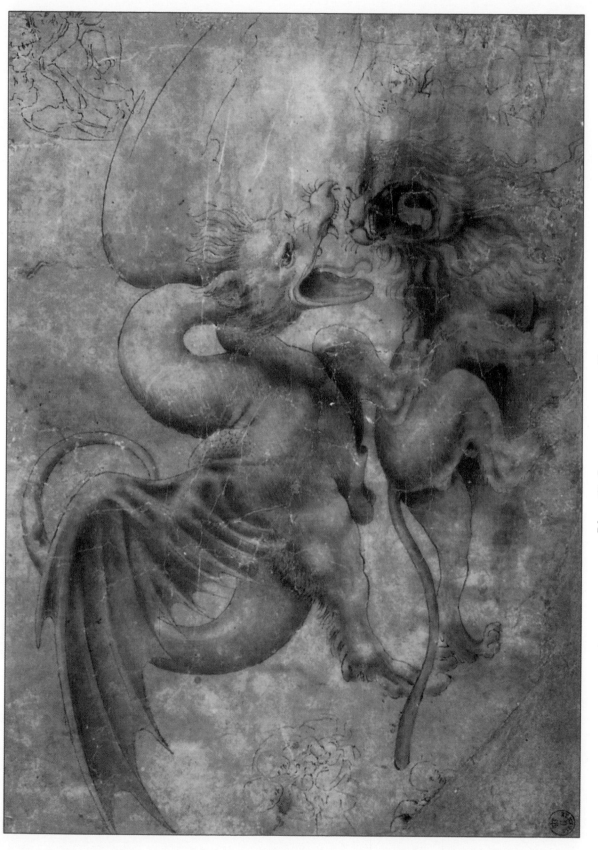

Plate 67. LEONARDO DA VINCI

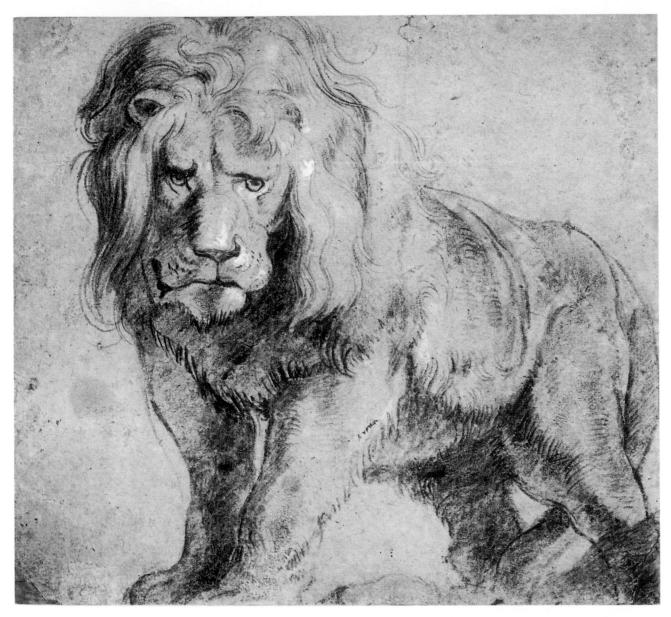

Plate 68. PETER PAUL RUBENS

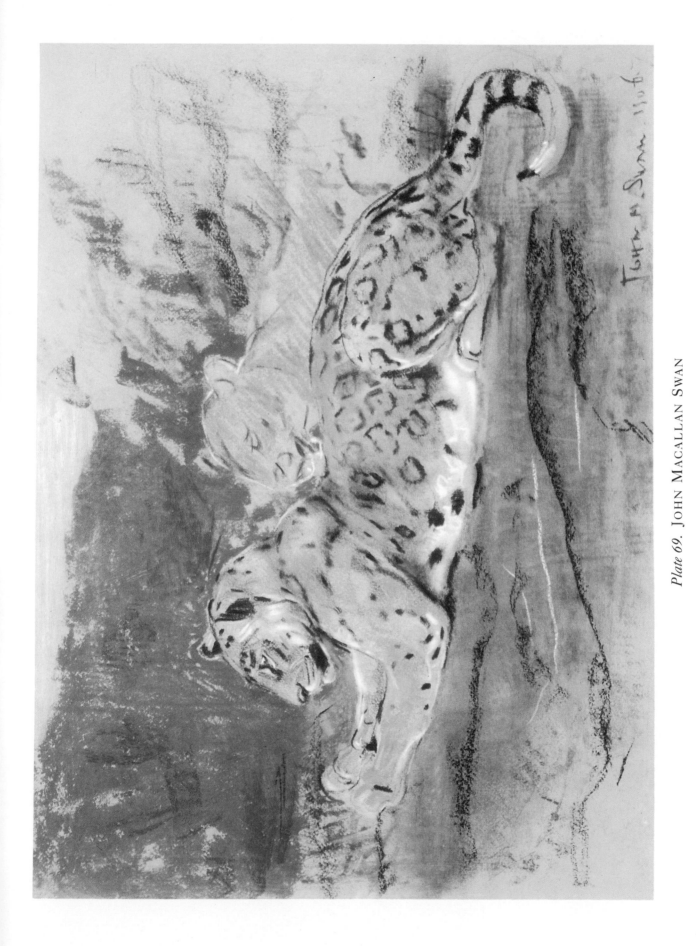

Plate 69. John Macallan Swan

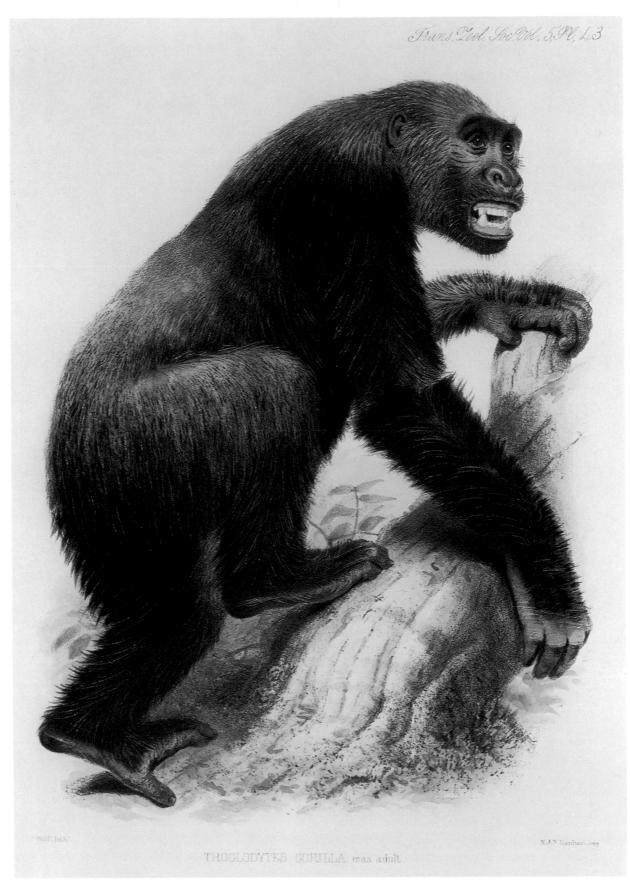

TROGLODYTES GORILLA mas adult.

Plate 70. Joseph Wolf

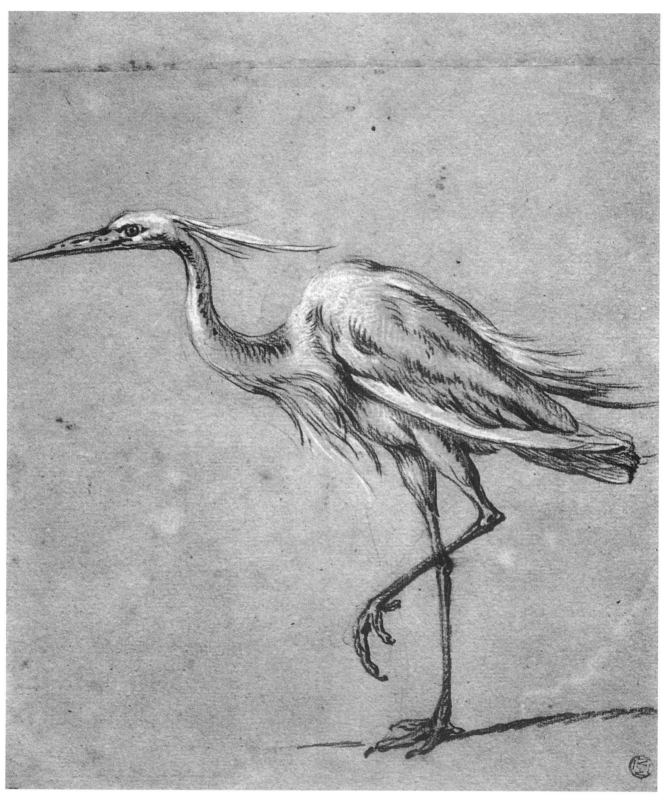

Plate 71. Jean-Baptiste Oudry

Plate 72. HERMAN PALMER

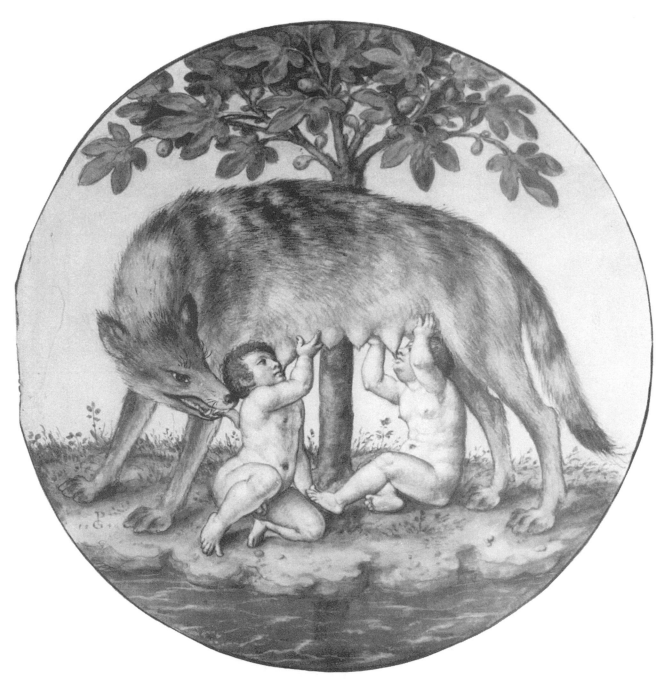

Plate 73. GEORGE PENCZ

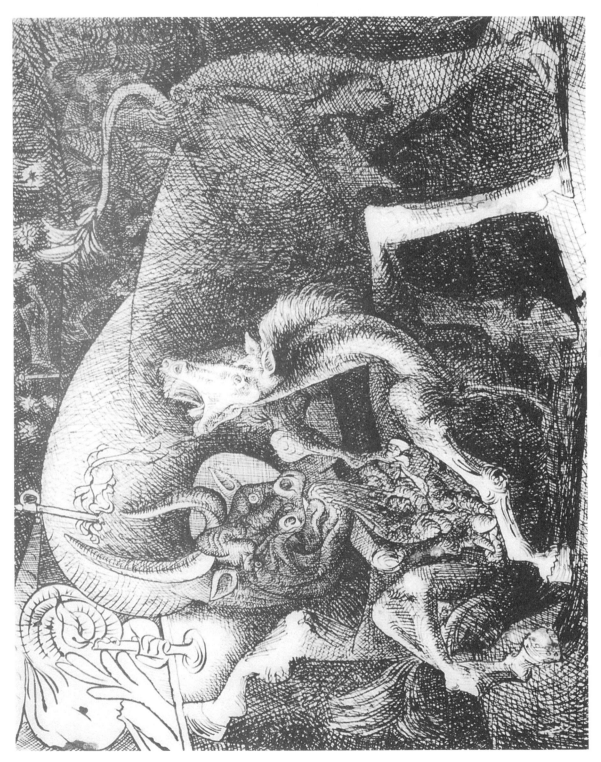

Plate 74. PABLO PICASSO

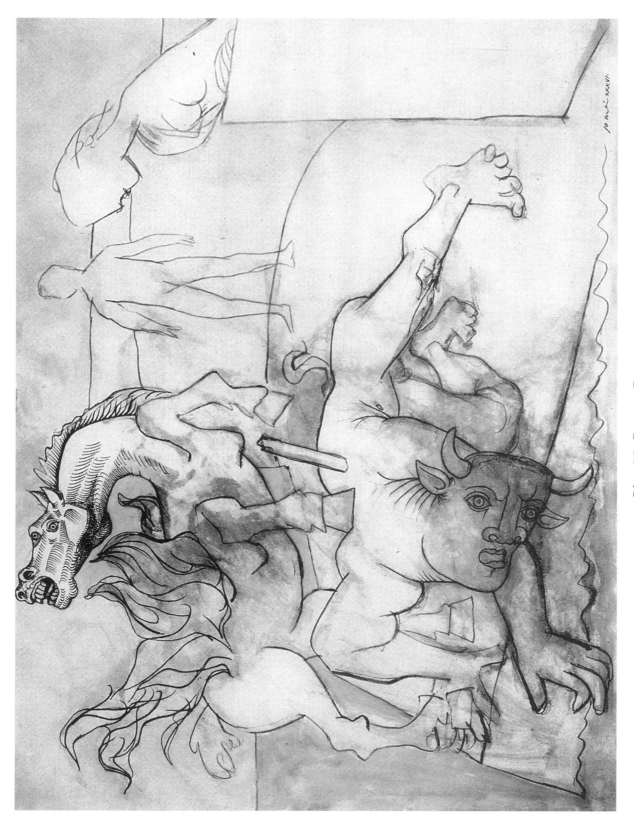

Plate 75. PABLO PICASSO

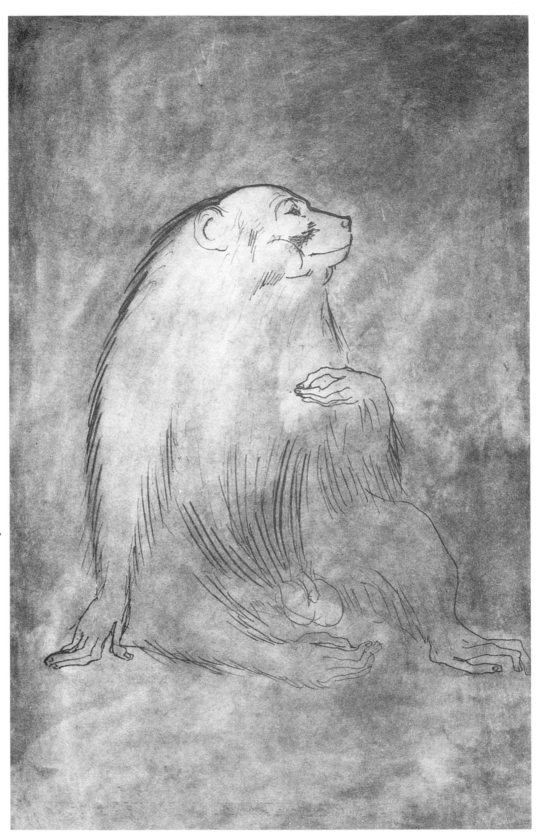

Plate 76. PABLO PICASSO

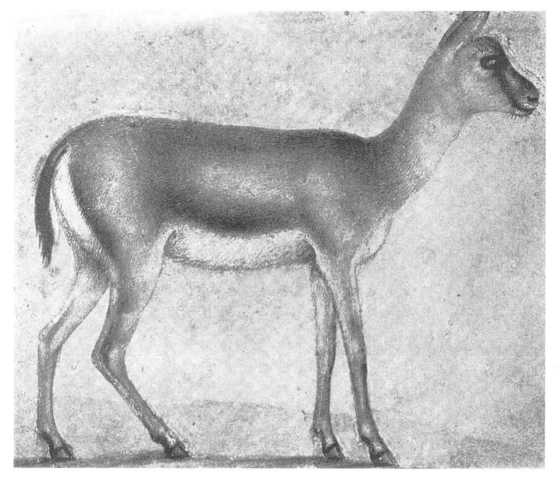

Plate 77. PISANELLO

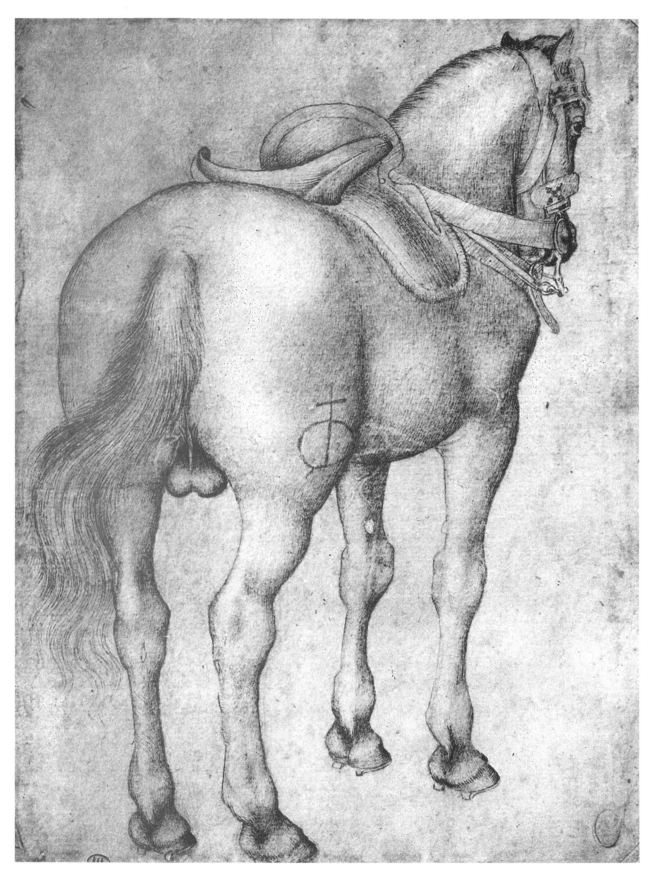

Plate 78. PISANELLO

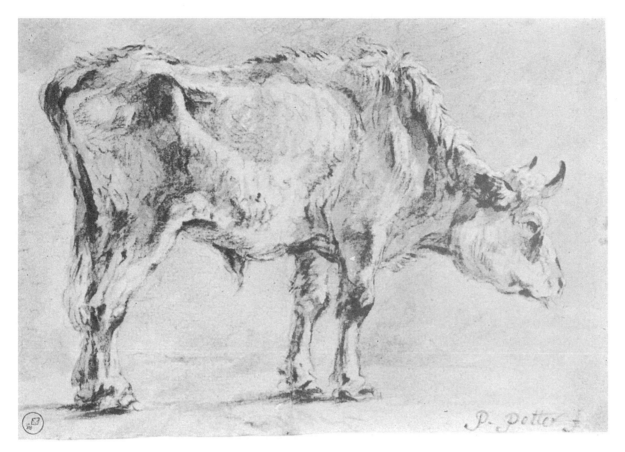

Plate 79. PAULUS POTTER

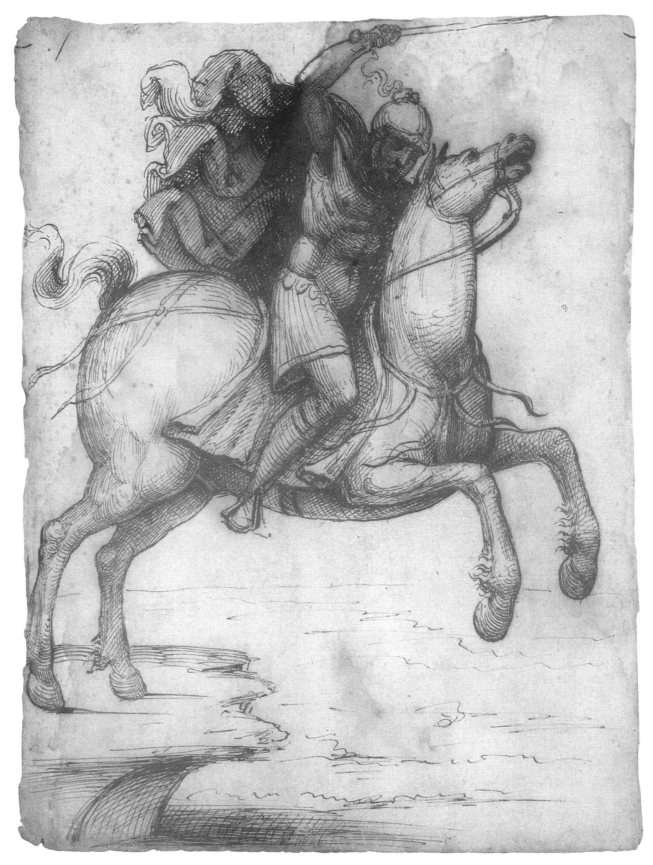

Plate 80. THE PSEUDO-PACCHIA, SIENESE SCHOOL

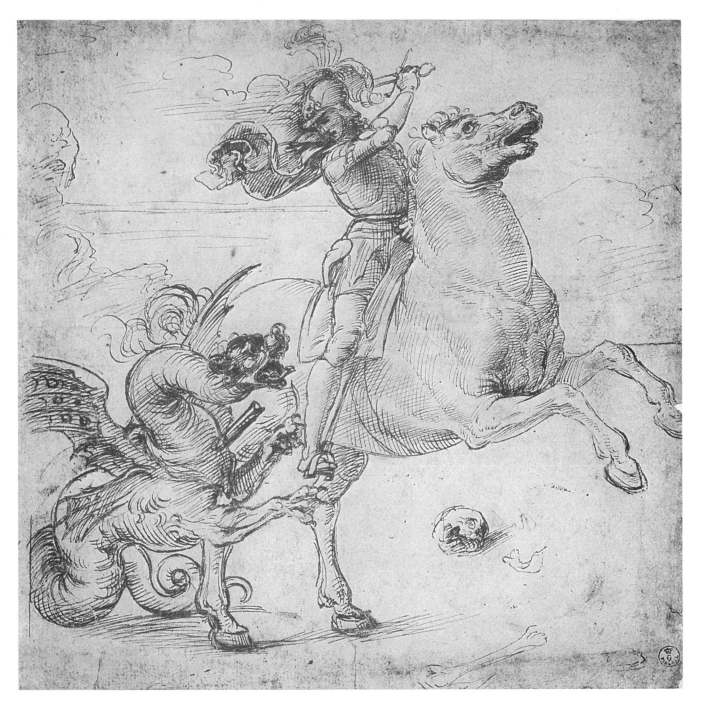

Plate 81. RAPHAEL

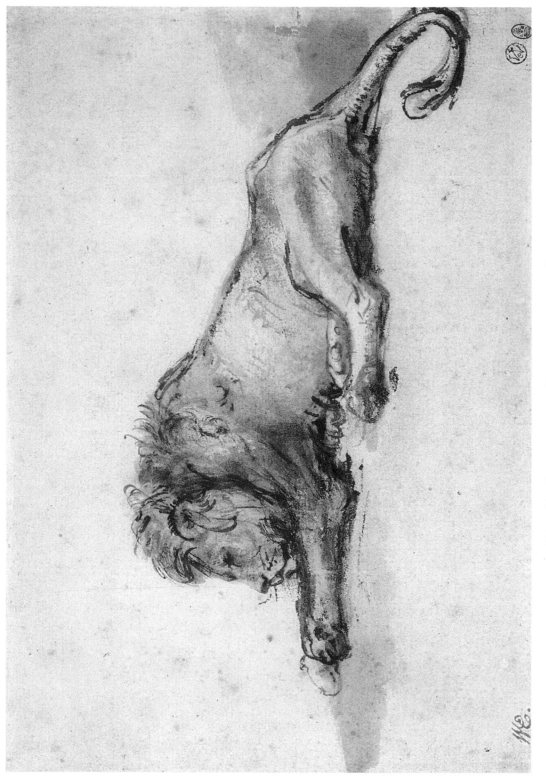

Plate 82. REMBRANDT HARMENSZ VAN RIJN

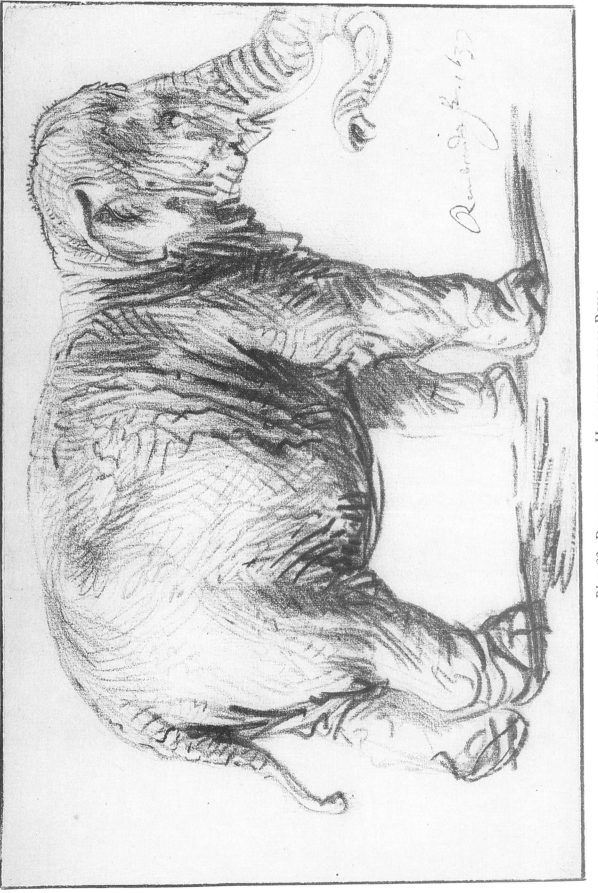

Plate 83. Rembrandt Harmensz van Rijn

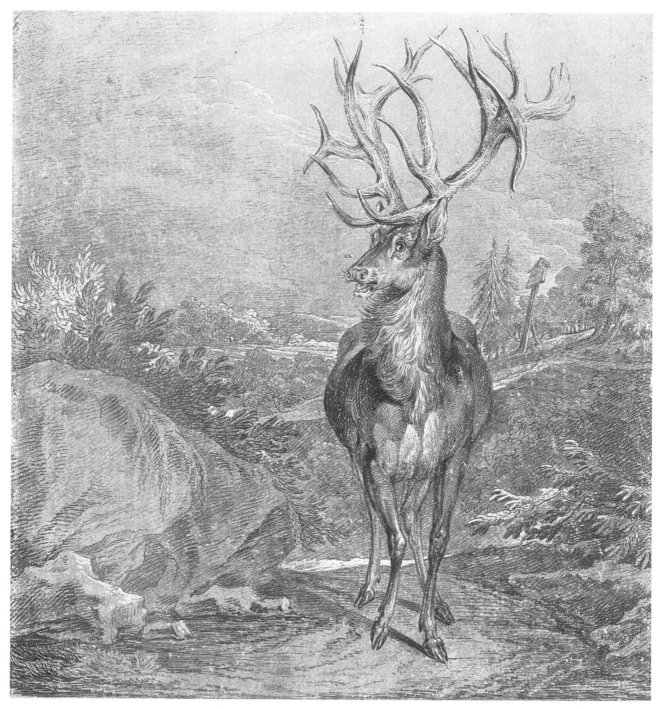

Plate 84. JOHANN ELIAS RIDINGER

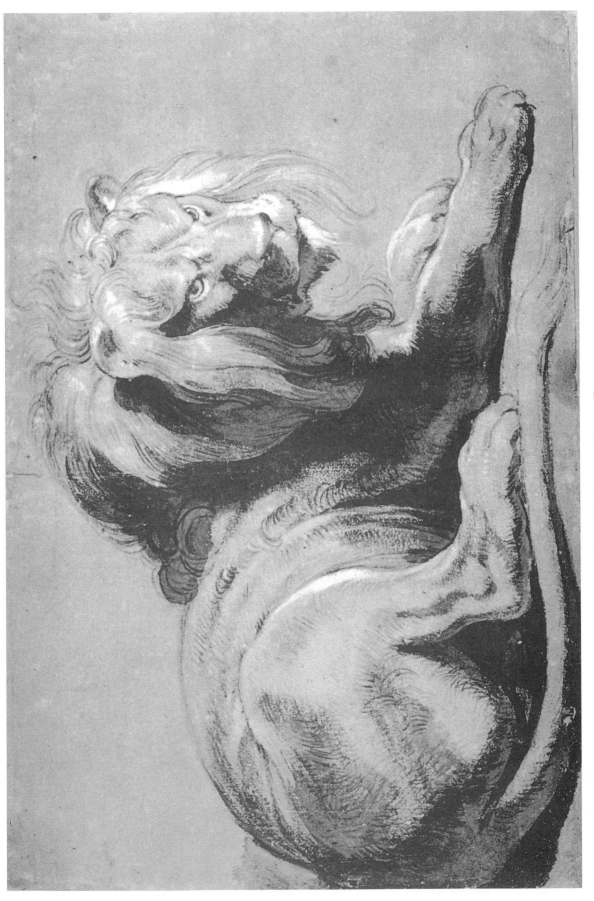

Plate 85. PETER PAUL RUBENS

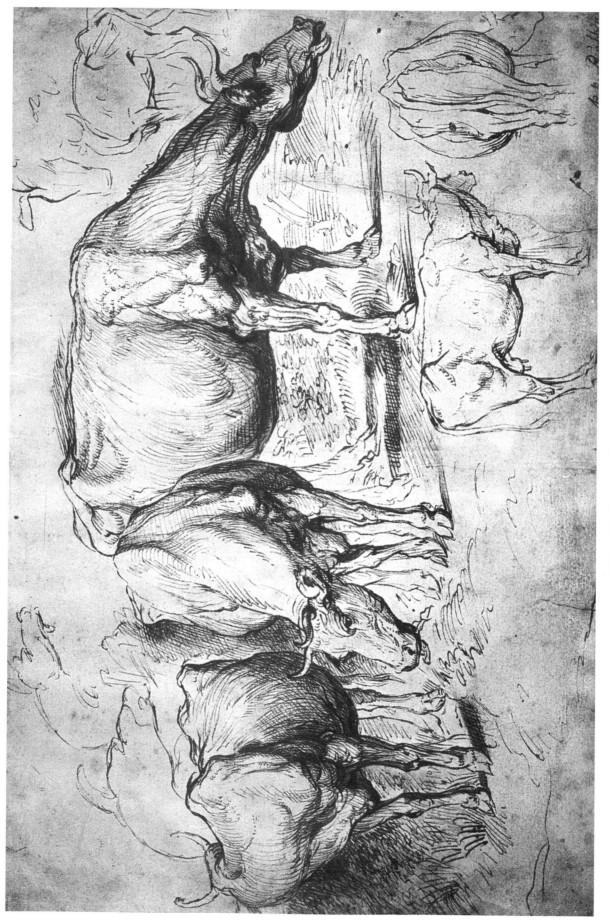

Plate 86. Peter Paul Rubens

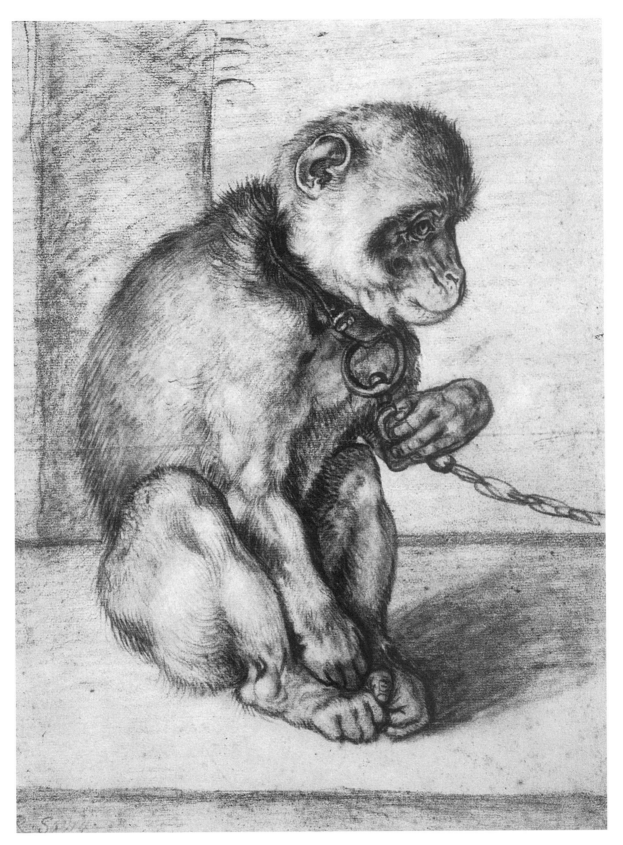

Plate 87. ROELANDT SAVERY

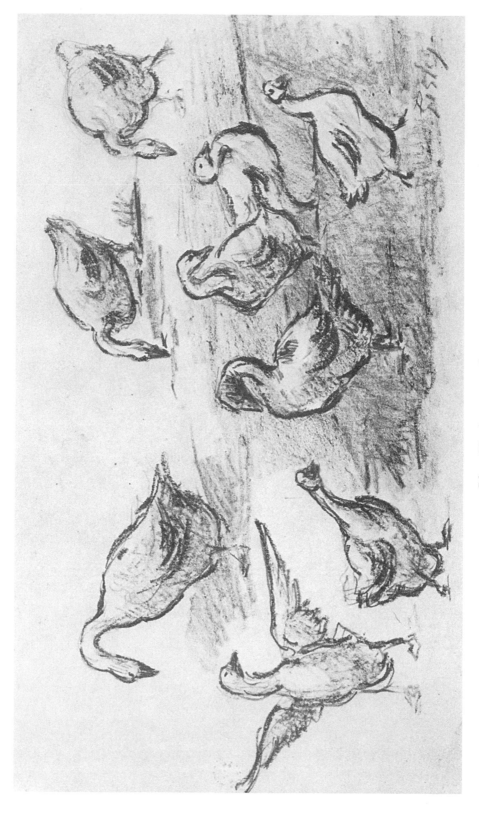

Plate 88. ALFRED SISLEY

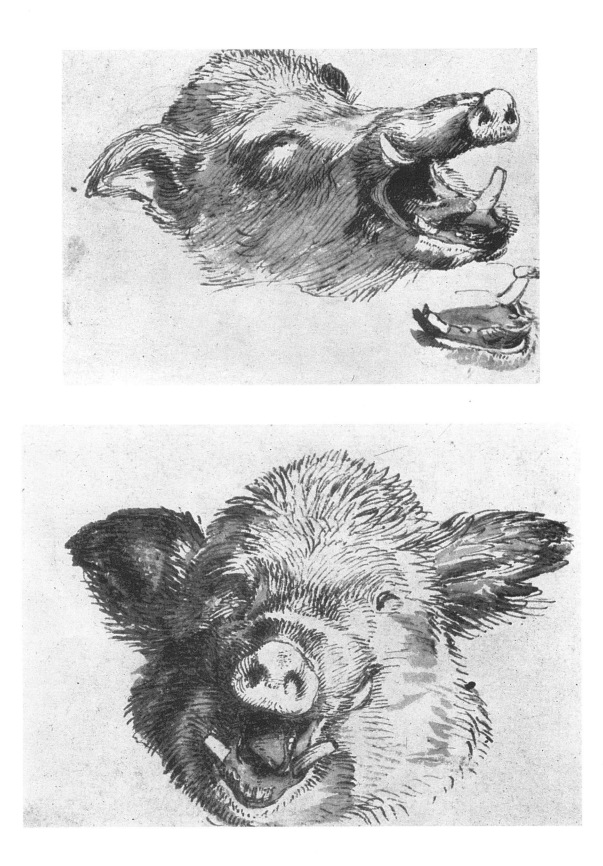

Plate 89. FRANS SNYDERS

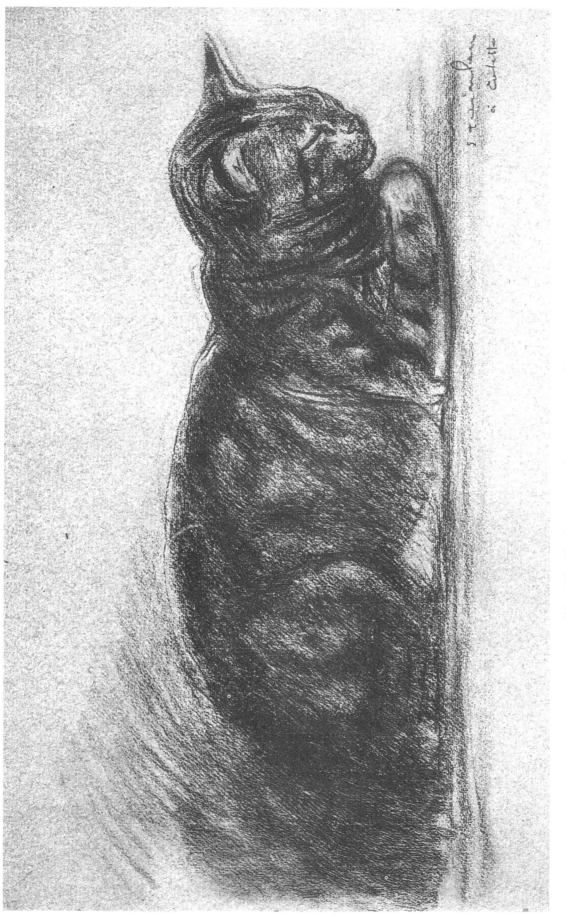

Plate 90. Théophile-Alexandre Steinlen

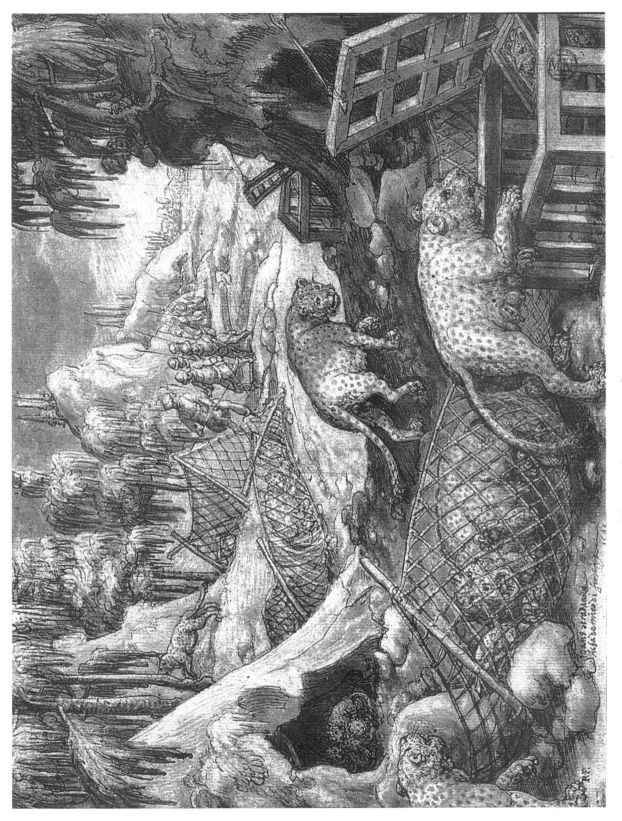

Plate 91. JOHANNES STRADANUS

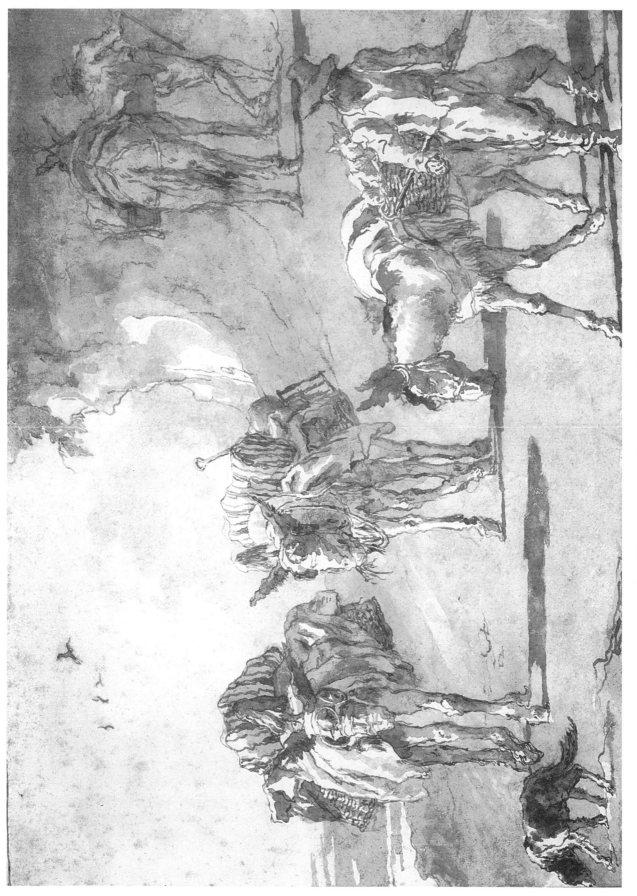

Plate 92. Giovanni Domenico Tiepolo

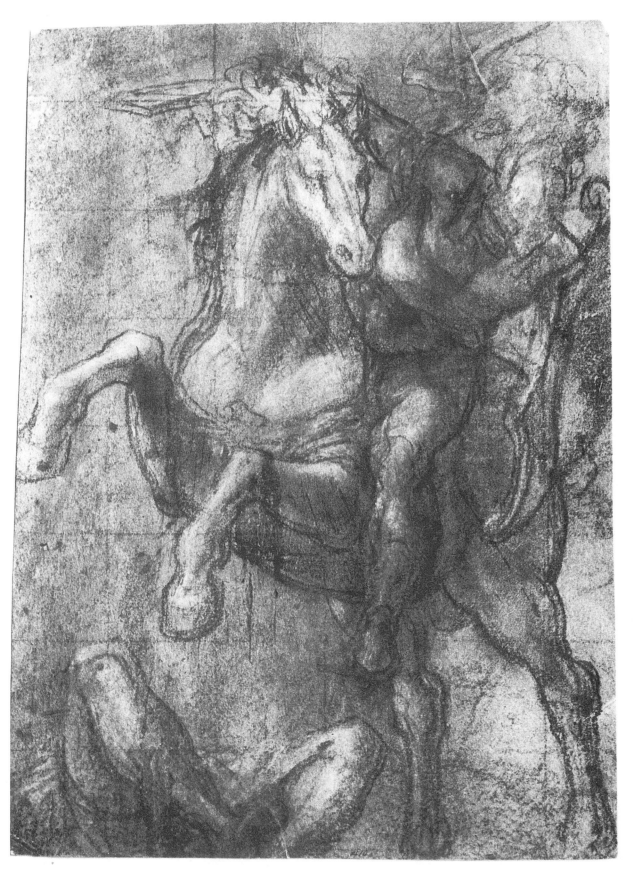

Plate 93. Titian (Tiziano Vecellio)

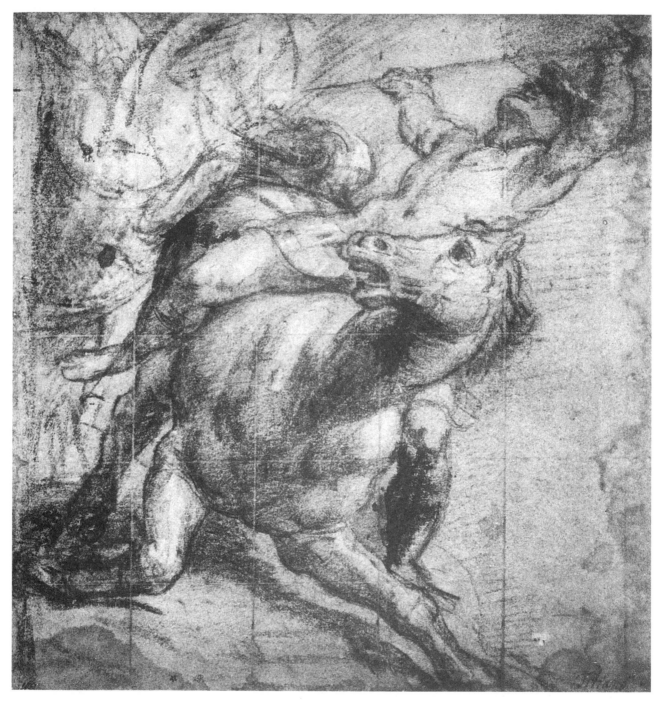

Plate 94. TITIAN

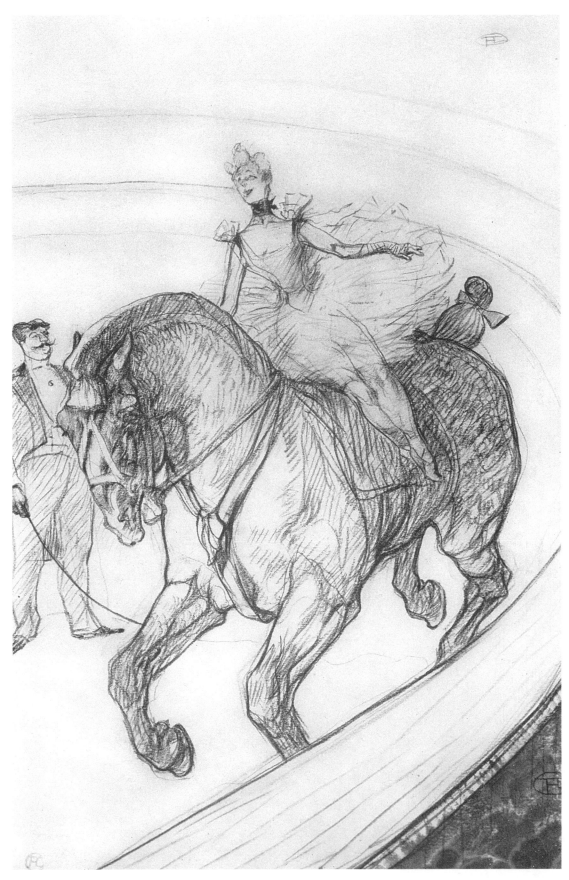

Plate 95. Henri de Toulouse-Lautrec

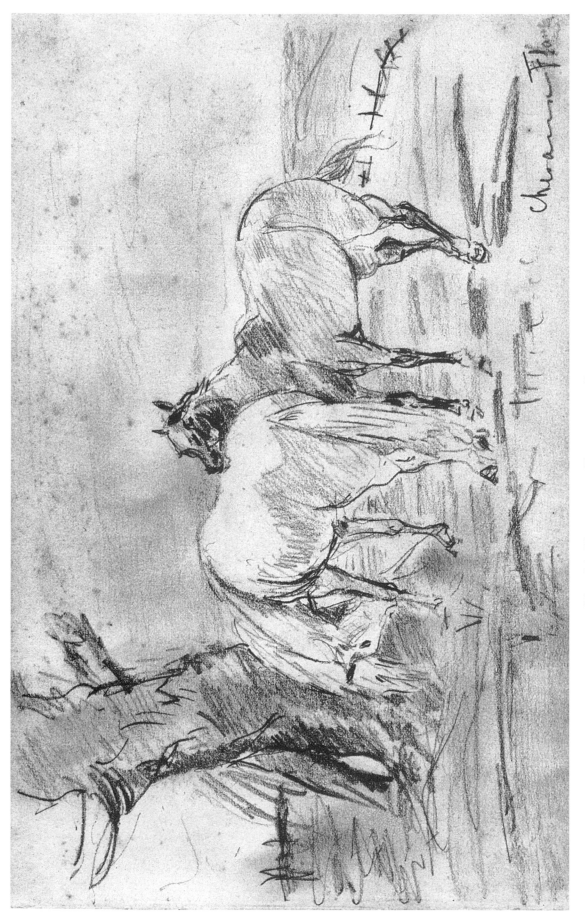

Plate 96. Henri de Toulouse-Lautrec

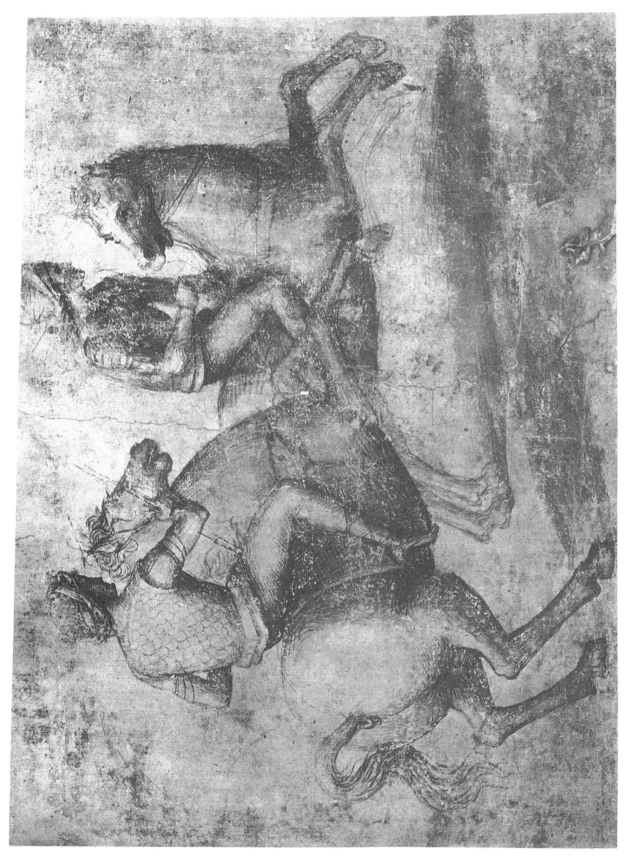

Plate 97. Umbrian Master, Anonymous

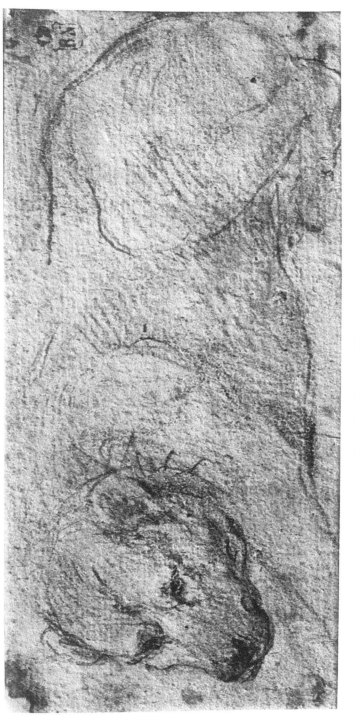

Plate 98. Diego Velázquez

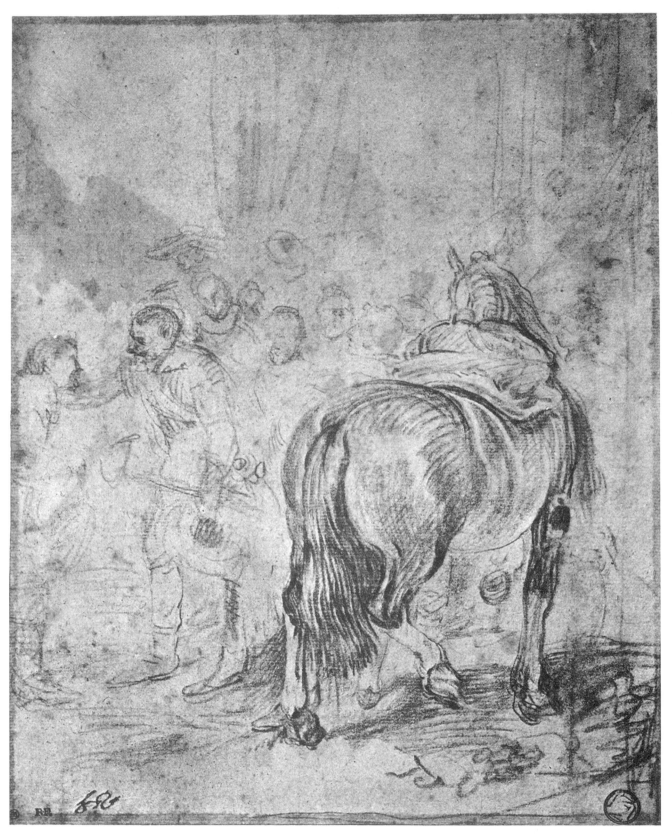

Plate 99. Diego Velázquez

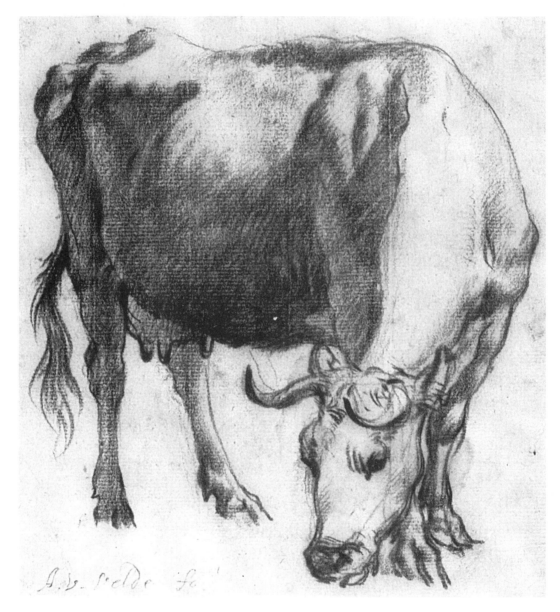

Plate 100. ADRIAEN VAN DE VELDE

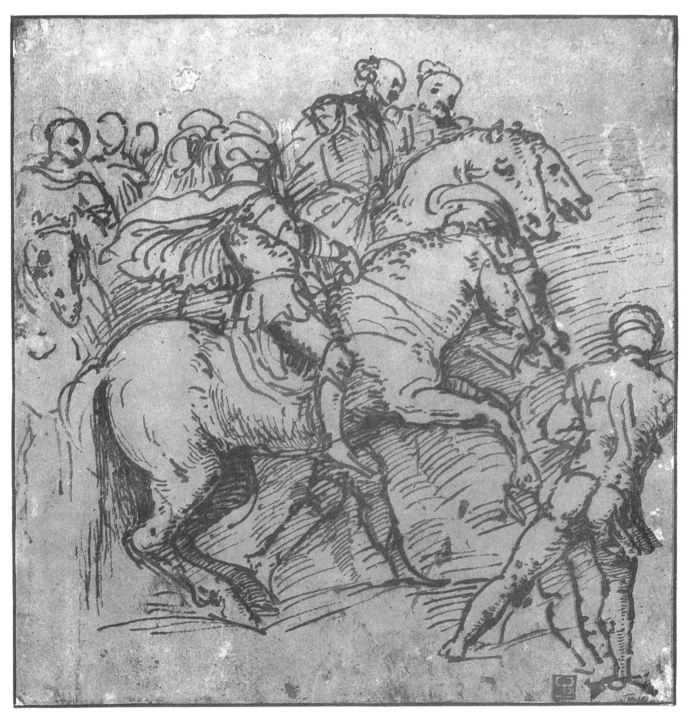

Plate 101. VENETIAN MASTER, ANONYMOUS